BEGINNER'S GUIDES

PAINTING

Landscape in Watercolour

PATRICIA MONAHAN

STUDIO
VISTA

ACKNOWLEDGEMENTS

The author and publishers would like to thank the following
artists, who have allowed us to use their work in this book:
Charles Bartlett, pp. 4–5; Gordon Bennett, pp. 28–9; Martin
Caulkin, p. 7; Anne Cherry, p. 7; Ronald Maddox, pp. 16–17;
Richard Pikesley, pp. 82–3; Ian Sidaway, p. 89; Adrian Smith,
pp. 92, 94; Stan Smith, p. 9; Bill Taylor, pp. 84, 86–7.
Special thanks are also due to Winsor & Newton for technical
advice and for their generous help with materials; to Stan Smith
for the step-by-step demonstrations on pp. 18–25, 34–9, 40–43,
48–53, 56–61, 62–7; to Adrian Smith for the artwork and step-
by-step demonstrations on pp. 26–7, 44–5, 46–7, 68–9, 70–71,
72–5, 76–81; and to Fred Munden for taking the photographs.

Studio Vista
an imprint of
Cassell
Villiers House
41/47 Strand
London WC2N 5JE

First published 1994

British Library Cataloguing in Publication Data
A catalogue record for this book is available from the British Library.

ISBN 0-289-80082-X (Pbk)
ISBN 0-289-80117-6 (Hbk)

Series editors: Jenny Rodwell and Patricia Monahan
The moral rights of the author have been asserted

Series designer Edward Pitcher

Distributed in the United States by
Sterling Publishing Co. Inc.
387 Park Avenue South, New York, NY 10016-8810

Typeset by Litho Link Ltd., Welshpool, Powys, Wales
Printed and bound in Great Britain by
Butler & Tanner Ltd, Frome and London

CONTENTS

Introduction

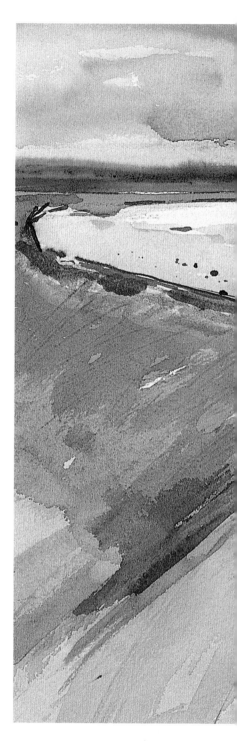

LANDSCAPE IS A glorious subject for the painter – endlessly fascinating, absorbing and constantly changing. You can return to the same location time and time again and always find something different, something new to enchant, tantalize and stimulate you.

Consider the changes that can occur on a single summer's day. Shortly after daybreak a haze hangs in valley bottoms and dewdrops glitter on cobwebs. Later, with the midday sun high overhead, shadows shorten, forms flatten and the horizon seems pale and distant. A brisk breeze blows up. Clouds scudding across the sun threaten rain. In the moisture-laden atmosphere, far-away hills become intensely blue. Crisply outlined against the lowering sky, they seem much closer to the viewer than before. Suddenly the heavens open and a squally shower veils the landscape, muting colours and reducing contrasts of tone. As evening approaches, the setting sun suffuses the western sky with a spreading blush of rose pinks and fiery reds streaked with orange.

Rich material indeed . . . and then there are the seasonal changes to take into consideration too.

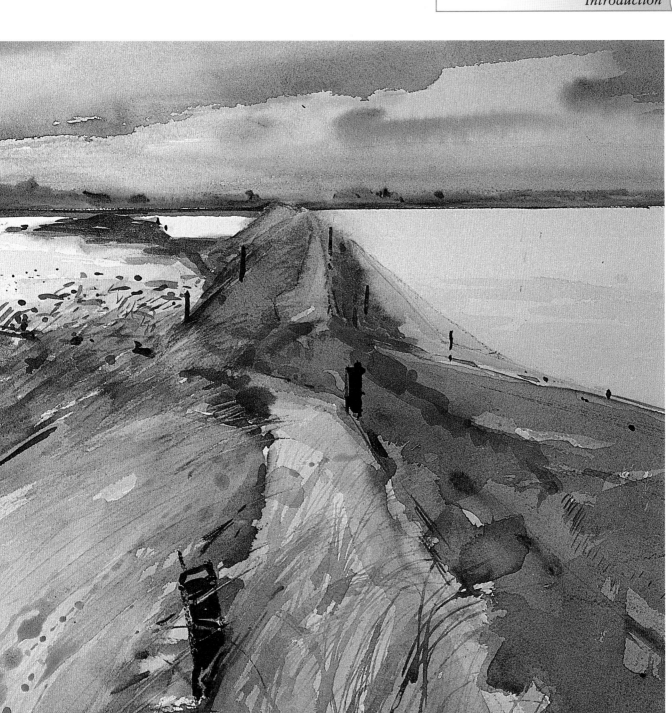

'Upper Reaches, River Blyth', 17 × 23½ inches (42.5 × 58.8 cm), by Charles Bartlett. The painting is not simply a description of the Suffolk landscape, but captures the atmosphere of the area: the emptiness, the wide open skies, the special quality of the light and the sheer poetry of the place.

WHY LANDSCAPE?

I would be lying if I said landscape painting was easy. But the rewards and pleasures are so great that any difficulties really don't matter.

Professional painters and Sunday dabblers return to the subject again and again. Undaunted, they struggle with the vagaries of the weather and the inconveniences of working away from home. In winter they cocoon themselves in seemingly endless layers of protective clothing, crouching beneath enormous golfing umbrellas, their easels staked to the ground or weighted down with rocks.

In summertime they don straw hats and sandals, and, laden with canvases, easels, flasks of tea and hip-flasks of something stronger, they tramp down country paths, over stiles, through herds of inquisitive cattle, up hill and down dale.

There are days when everything goes wrong. Paint dries either too quickly or too slowly, rain speckles an almost complete watercolour, a painting falls 'butter-side' down on to grass or gravel. But still they persevere.

Why do they do it? Well, *I* do it because I find landscape painting challenging, stimulating and capable of so many interpretations. There is always some discovery to make, some new path to explore. I'm never at a loss for something to paint and I'm never, ever bored when painting out of doors. I love the sights, sounds and smells of the countryside – the soothing murmur of a small stream, the hum of insects and the sound of a combine harvester working several fields away. I like the sense that I am part of a long tradition, and the way landscape painting heightens both my awareness of the world in which I live and my appreciation of the work of those who have recorded it.

I like the richness of the subject matter, which encompasses everything from the absorbing detail and textures of a rotting, moss- and lichen-covered tree stump to the grandeur of a steep-sided, glacier-gouged and rain-sodden valley in Ireland, or the romance of the rolling, manicured downlands of southern England.

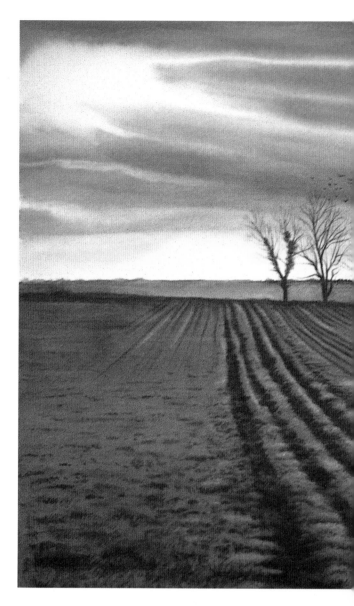

And don't think you have to journey to remote locations to find 'landscapes'. I open my back door and see a small flint-walled garden with houses beyond – a symphony of subtle greys in winter, full of bright colour and strong shadows in summer. From the upper storeys I'm presented with a patchwork of tile and slate roofs, a church spire poking through in the distance. The front of the house provides me with yet more vistas and this wealth of material is available without even stepping out of doors.

There are 'landscapes' all around you if you just open your eyes – in parks and cemeteries, on the seafront, on suburban streets, along inner-city canals, and in the industrial wastelands which girdle our towns and cities.

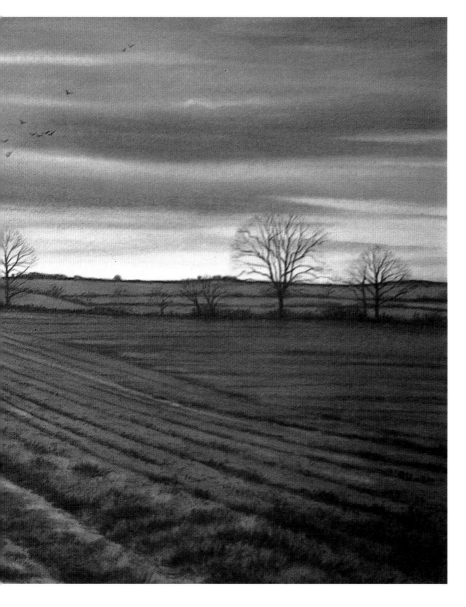

△ The artist Anne Cherry is particularly concerned with the effects of light on the landscape. In 'Sudden Flight' she describes tilled farmland near her home, illuminated by a weak, wintry sun. She rarely finishes a painting on location, but works from sketches made on the spot with lots of colour notes.

▷ 'Property for Sale' is a wonderfully moody painting by Martin Caulkin. Many of his works are concerned with derelict buildings and abandoned machinery within a landscape setting.

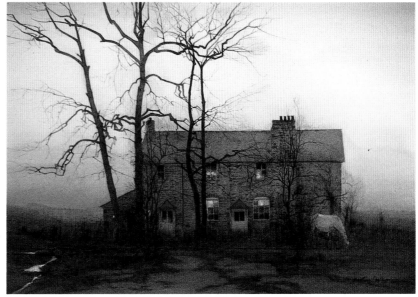

WHY WATERCOLOUR?

Watercolour has many qualities which make it an almost perfect medium for the landscape painter. It is beautiful, exciting, expressive, unpredictable and immensely flexible. It can be used for quick sketches, as washes of colour on line work, or for large finished paintings.

There is a huge repertoire of watercolour techniques and, if you are prepared to experiment and take risks, you can find all sorts of short cuts and tricks which will surprise and please you, while also giving your work liveliness and personality.

Watercolour can be used to create works in a wide variety of styles. Wildlife painters and illustrators, for example, often favour a precise, tightly wrought style in which the paint is applied in a series of carefully controlled washes, with the detail added wet on dry, using small, controlled brushstrokes. But watercolour can also be used to create big, bold studies in which the paint is applied as wet washes, with broad gestural brushstrokes. The colour can be dripped, dribbled, splattered and spattered. You can tip the board to make the paint run, or use a hairdrier to send the colour swirling across the surface of the paper. Used in this way, you can create paintings which are expressionist, impressionist or move towards abstraction.

So what exactly is watercolour? For those who are unfamiliar with the medium, the term watercolour – or, more accurately, 'pure' watercolour or 'transparent' watercolour – is used to describe a water-soluble medium bound with gum arabic. It is available in two forms – as semi-moist pans and as creamy tube colour.

In both forms the paint is diluted with water to create thin washes of colour, and applied to white or creamy paper. The white of the paper shows through the thin films of colour, giving the best watercolours a special translucency and shimmering brilliance which lend themselves to the subtle and shifting tones and colours of landscape.

With watercolour it is important to remember that the only white and the brightest highlights you

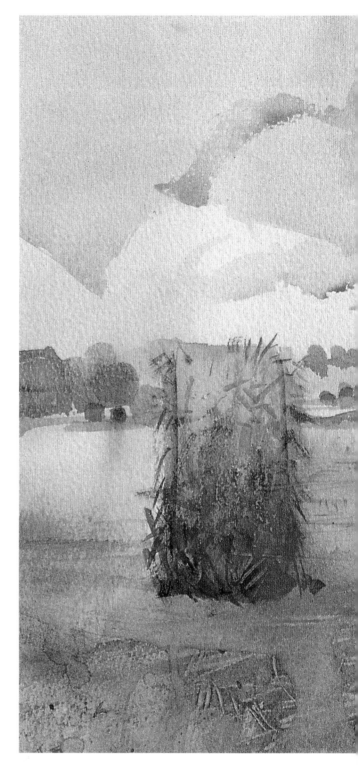

can have are formed by the white of the paper. To succeed with watercolour you must grasp the notion of working from light to dark. You have to reserve white and pale areas, gradually building up the darker tones with overlapping layers of colour or darker washes. It takes a bit of practice to get this right, but it's not as difficult as it sounds.

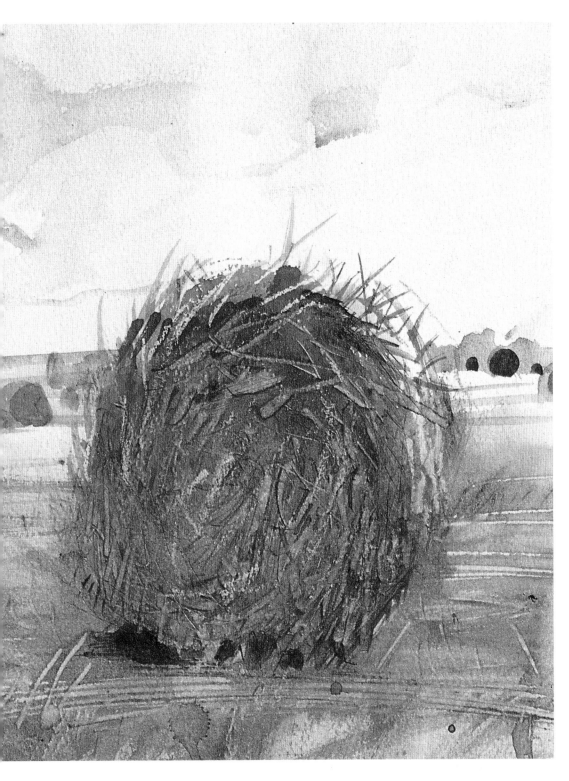

There is another form of watercolour, which is opaque. Called body colour, or gouache, it is available in tubes and sometimes in hard pans. Because gouache is opaque, you can overpaint dark colours with pale, laying, for example, light highlights on to dark areas. It also allows you to make corrections.

Stan Smith was entranced by the monumental quality of these 'Big Bales'. Gum arabic was used to create texture.

In this book we deal primarily with pure watercolour, but in places the artists have created body colour by adding white paint to watercolour, thus rendering it opaque.

BASIC KIT

One of the advantages of watercolour is the relative simplicity of the materials required. This is particularly evident and useful when you paint away from home.

A kit for out of doors

The watercolour painter can travel light. All you really need are paints, brushes, water and paper. Semi-moist pans of solid colour come into their own when you work away from home. Tube colours are great for large-scale work, but you need lots of mixing saucers and palettes. With solid pans, all the colours can be seen at a glance, and you can mix washes quickly, without having to fumble with caps and squeeze out paint.

The ideal box of colours would consist of a maximum of twelve pans or half-pans in a box with a lid and a flap which fold out to provide mixing spaces. The lids of watercolour boxes are recessed for this purpose.

You can find tiny boxes of watercolour – small enough to fit into a shirt pocket – which contain quarter-pans. Winsor & Newton call their sketching boxes 'Bijou' and offer two – one with twelve colours and one with eighteen. Some people find quarter-pans difficult to work with, because they are so small. If you use a large brush, stick to half-pans or pans.

Then, of course, you will need brushes. This is a difficult area to advise on, because there are so many brushes to choose from and in the end the decision depends on you and your style. If you are setting up from scratch, choose three round brushes in pure sable, if you can afford it, or in a mixture of synthetic and sable. Buy the best you can afford. Winsor & Newton's Sceptre Gold range is a good example of the mixed-fibre brushes. Start with numbers 1, 6, 10 and 14.

Pads of paper are easy to carry, especially the blocks which are gummed on four sides and don't need to be stretched. Many artists stretch paper on lightweight boards for outdoor work, but the advisability of this depends on what you are going to do, how far you have to carry your stuff and whether you have transport.

Whether you need an easel or not will depend on the scale at which you work. If your work is small, you can usually manage by balancing a pad on your knee, a wall or a convenient tree stump. For large-scale work, you will need an easel. Easels for watercolour need to be used in a horizontal

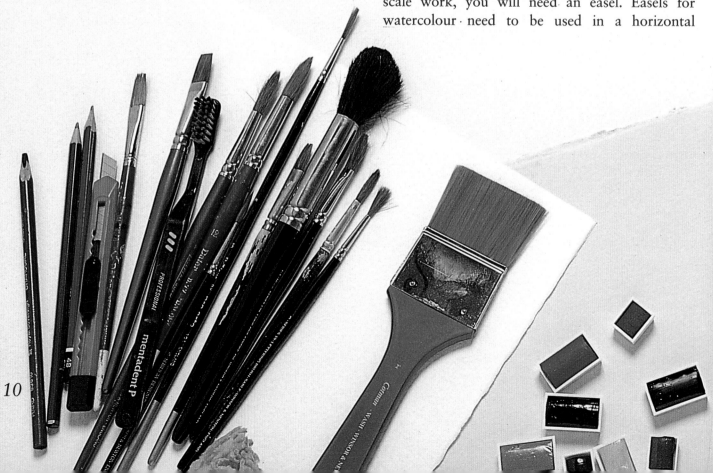

position for washes, so check this when making a purchase. Wood sketching easels are quite cheap and light. Aluminium easels are also light, and are much easier to set up and adjust, but they are quite a lot more expensive.

You will also need containers for water, a bottle to carry it in and two jars – one for mixing washes, one for cleaning brushes. Plastic bottles are lighter than glass – save mineral-water bottles. Glass jars, though heavier than plastic, are more stable. You will need some rag, kitchen paper, a pencil, an eraser, a craft knife and a bag to carry everything in.

A kit for working in the studio

The equipment you use in the field may well suffice for working at home, but generally you will want to work on a larger scale indoors. You will need sheets of paper, boards, palettes and a collection of tube colours for mixing big washes. Gummed tape is used for stretching paper; masking tape is useful for masking and for taping heavy paper to boards. Gum water and gum arabic are media which can be

added to the paint to give it a sheen. They also allow you to develop textured effects, and to wet the paint once it is dry – to lift it off to create highlights or textures, for example. Masking fluid is useful for covering and thus saving areas that are to remain light or white while you continue working around them. A white candle, crayon or oil pastel can be used for resist techniques, and pencil, ink and coloured pencil can be combined with water-colour very successfully. Collect and experiment with dip pens, quills, reeds and any other drawing implements you come across.

COLOURS FOR LANDSCAPE

There is a lot to be said for working with only a few colours – artists call this a 'limited palette'. Paints are expensive, and cost is an important factor for many people, but there are other reasons for restraint.

The more you know about the materials you use, the more you will be able to get from them. If you start with just a few colours, you can really get to know how they dilute, overpaint and mix. You will be forced to experiment with mixes to get the range of colours and tones you need from your limited selection. If you have a large selection, with four or five yellows, for example, you will never need to explore the full potential of each one. You may get lazy and, rather than forcing yourself to find just the right colour, make do with an approximation because it is there in the tube or pan.

If you use a limited range, you will become so familiar with your colours that you can use them without having to think about it – and at that point you will be able to focus on the really important thing, which is the subject in front of you and your interpretation of, and response to, it.

In Chapter 4 I talk to three artists about their approaches to landscape and watercolour. You'll find that they all work with a limited range of colours.

One of the delights of watercolour is its incredible brilliance and clarity, and anything which detracts from that should be avoided. The best colour mixtures are made from two main colours, with perhaps a touch of a third and fourth for more complex, muted shades, like greys and neutrals.

▷ **A starter palette**
The following colours will allow you to mix all the colours you need for a landscape, including a wide range of greens. The colours are: ivory black, cobalt blue, cerulean blue, Prussian blue, raw umber, yellow ochre, cadmium yellow pale, alizarin crimson.

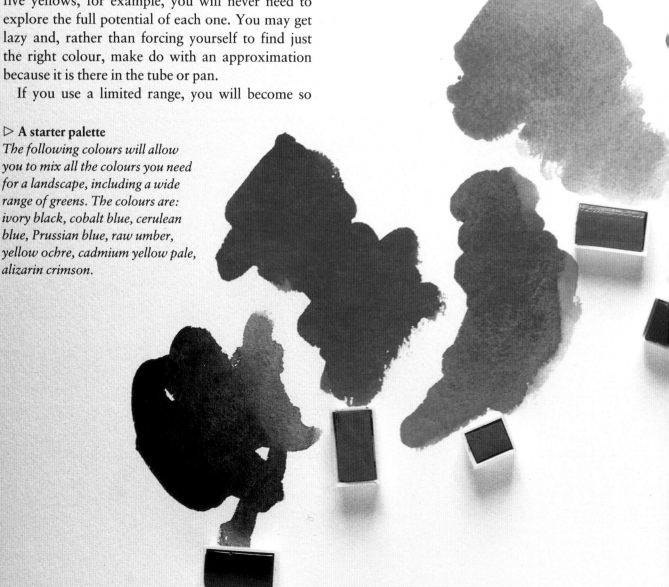

Mixing greens

Green is the most important colour in the landscape-painter's palette, and causes the most problems. Proprietary greens are useful but don't give you the range you need to capture the colours of nature.

To explore the possibilities of one pair of colours, see how many shades of green you can get from ultramarine and cadmium yellow pale, for example. Then add a touch of raw sienna to each of the mixtures to produce a more muted tone.

An effective way of creating lively greens in a painting is to underpaint them with another colour. Because watercolour is transparent, the underlying colour will modify the top colour, adding interest and acting as a visual link between different areas. You will see this clearly demonstrated in the project on page 48, 'The Long Man of Wilmington'.

△ **Greens mixed from viridian**
Some useful greens can be mixed from viridian – a rather transparent bottle green which is a bit difficult to use in its pure form. Clockwise from top left, viridian, viridian with: raw sienna, lemon yellow, cadmium yellow, yellow ochre, burnt umber.

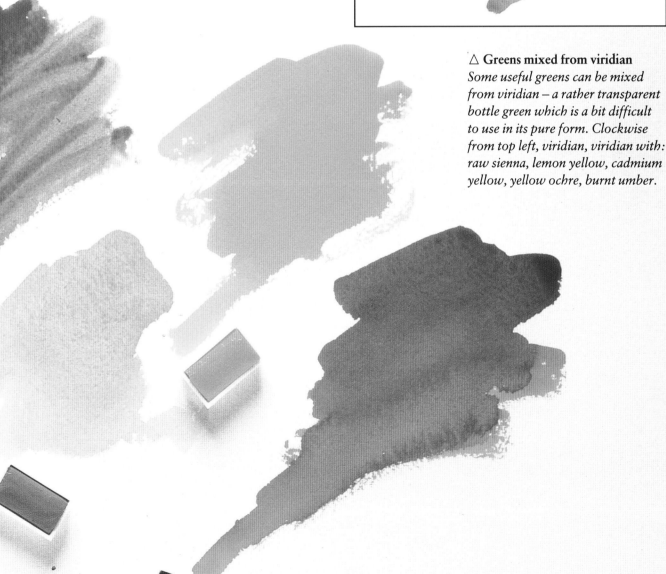

COMPOSITION

A successful painting is both complex and many-layered. It must inform, entertain and communicate. A good painting grabs your attention and, having done so, holds it.

There are several ways in which artists will achieve these ends, including the skill with which they render the image, describe the form and imply space. The painterly qualities of the work are also important – a meticulously rendered surface or luscious layers and swirls of colour can give real pleasure. These qualities are obvious to even a fairly uninformed viewer. But there is another area which is often overlooked, even though it is more powerful than all the others.

'Composition' concerns the way the elements of a painting are organized within the picture area. It is the underlying geometry of a painting; an abstract quality which gives it tension and harmony, and is present in other areas of the arts – in great music and architecture, for example.

Why is composition so important? There are many reasons. A well-composed painting has an internal harmony – the individual elements hang together to create a convincing and pleasing whole. Composition provides the framework upon which the painting is constructed and gives it solidity and coherence. Get this right and you are well on the way to success. Compositional devices can be used to give a painting impact, to create rhythms and stresses, to draw attention to important passages and to lead the eye around the painting. A badly designed painting has a flabby, unstructured quality – the eye doesn't know where to start, and either wanders aimlessly over the picture surface or ricochets from one area to another.

So how can you exploit this powerful device and use it to your advantage? The shape of the picture is the first compositional decision you make. Most paintings are based on a rectangle, but there are different sorts of rectangle, each of which has a different impact on the viewer and suggests different moods and emotions. A square, for example, is compact, contained and stable. It invites the eye into the centre and focuses it there.

A single image placed in the centre of the picture (above) rarely makes an interesting composition. Above and below right, the trees lead the eye in.

An upright or 'portrait' format, on the other hand, has an incipient instability – because it is tall, it might just tip over. There again, it encourages the eye to roam up and down, and has a soaring, inspiring and imposing quality that has been exploited by great religious painters throughout the ages, and by portrait painters. The broad, expansive 'landscape' shape, which is wider than it is tall, is inherently stable. It invites you in and allows the eye to wander from side to side and go deep into the painting. It lends itself particularly well to landscape painting, though there is absolutely no reason why you shouldn't paint a landscape within a square or a portrait shape – and indeed some images cry out for those shapes.

A successful composition forces you to look at it, so you must provide viewers with a way into the painting (this is usually at the bottom, but not

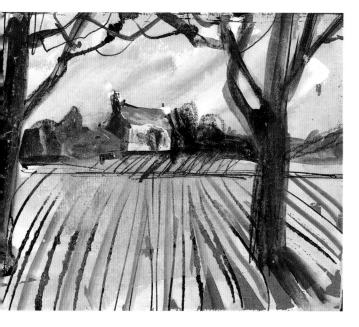

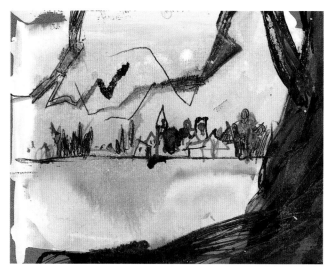

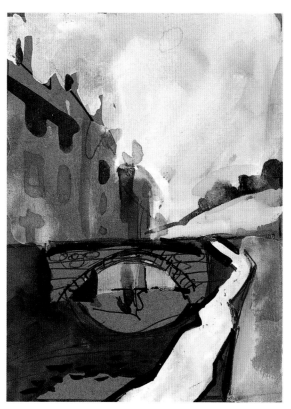

Avoid a rigorously symmetrical composition. A pathway and bridge (above) are used as compositional devices, drawing you into the picture. Horizontal divisions are important in this 'portrait' format, and particularly so in the picture below.

necessarily so). Once you have got them there, you must hold their interest. A painting should also have a focus, a single important point to which the eye returns again and again. In the painting of the bridge on pages 24–5, for example, the eye is drawn to the area contained by the circle created by the bridge.

A good way of analysing composition is to lay a piece of tracing paper over a painting and trace off the main stresses and rhythms, looking for repeated angles and shapes, and for the points at which one line connects with another. A painting can also be analysed in terms of its tonal structures, which provide a hidden compositional theme. To 'see' this, lay a piece of tracing paper over a picture and block in the dark areas with pencil. You will end up with a complex of interlocking abstract shapes.

Try these tracing exercises with reproductions of Old Masters. You will learn a lot.

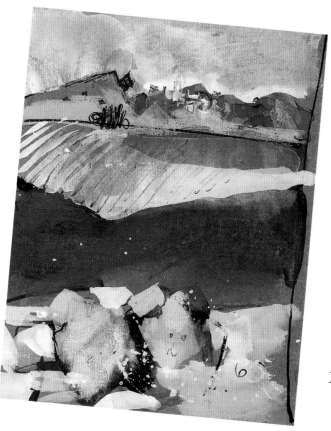

15

Working out of doors

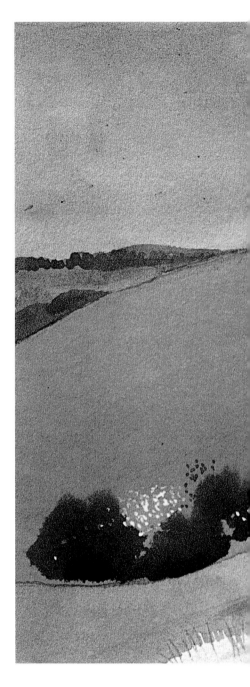

IN CHAPTERS 2 AND 3 there are eight step-by-step projects photographed on location and in the studio. These give you the opportunity to look over the artists' shoulders and to share some of their thoughts as they work. The best way to use these projects is to study the text, captions and pictures, and then find a similar subject. You will learn more by doing your own painting and not simply copying.

If you do make a copy, don't be too literal. Personalize the picture by changing the composition, leaving things out and adding bits from another picture, from your own sketchbooks or from photographs. Use the original as a jumping-off point.

Be aware of the paint, the support and the feel of the brush, and allow them to lead you in new directions. Be prepared for the 'happy accident' – the unplanned bleeding of one colour into another, the unintentional blotting or splashing of paint. Leave it, blot it or blow it with the hairdrier. Don't be afraid to take risks, maybe to make mistakes. It is the only way you will learn. And if the picture really is a disaster, simply abandon it and start again.

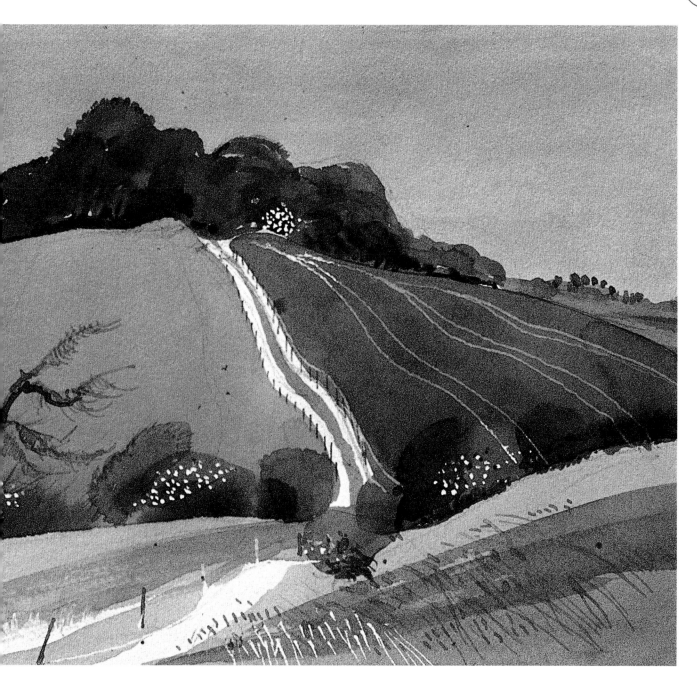

△ *'Chalk Track, King Down, Dorset' by Ronald Maddox. In this painting the artist explores a favourite theme: pattern and shape within the landscape. He simplifies and edits to create a satisfying composition which has drama.*

◁ *Don't encumber yourself with too much equipment: here an artist sets out for a day's work with a bag of equipment, an easel and a drawing board.*

17

TECHNIQUES

FINDING THE SUBJECT

One of the daunting things about landscape painting is the sheer size of the subject. You have to choose a view, decide where your picture will begin and where it will end, and what you will include and what you will leave out. There are, though, a few tricks of the trade to make this process easier.

The viewfinder
This is a small rectangular frame cut from stiff card. It doesn't have to be very big – mine is 7½ × 9 in (19 × 23 cm), with an aperture 4¼ × 6 in (11 ×

15 cm). By viewing the landscape through this frame, you can isolate sections of it to assess their picture-making possibilities. By moving the viewfinder further away from your eye, you will frame a smaller section of the vista.

Exploratory sketches
Quick sketches made on the spot allow you to explore the compositional possibilities of the landscape. Use pencil, coloured pencil, felt pen, ballpoint or whatever you have to hand. Find a focal point – in the examples shown here it is the bridge – and see what happens when you move it around the picture

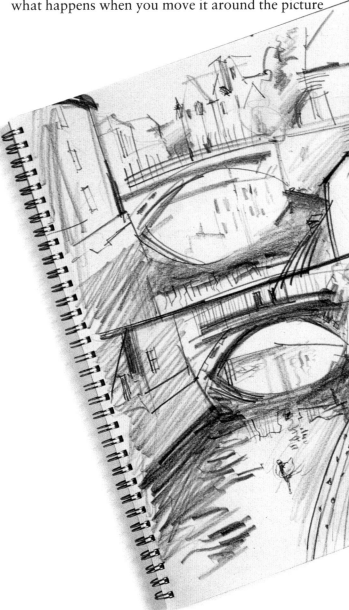

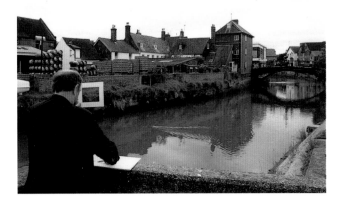

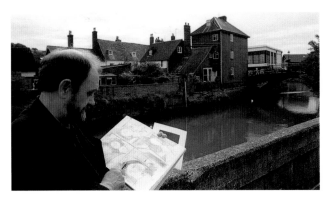

△ *Use a viewfinder and sketches to explore the compositional possibilities.*

area. Look for rhythms and stresses within the subject, and see how these can be contained within the rectangle of the picture area.

Screw up your eyes to see the way light and dark tones are distributed, blocking in the dark areas loosely. You can annotate the sketch with infor-mation about colour, weather conditions and the direction of the light. All this will be useful when you start work on the picture.

Using L-shaped masks

Card masks allow you to isolate a section of a sketch or drawing so that you can see how it works as a picture. For example, if you make a large drawing, you might decide to crop in to a small section of it and use that as the basis of a painting.

The most flexible sort of mask is made out of two L-shapes cut from card. These are laid over a sketch to form a rectangular frame. You can adjust the size and shape of the area masked.

◁ *The first drawing (top left) is a fairly conventional portait of the bridge, putting it and its reflection firmly in the middle of the picture. The sweep of the wall on the right leads the eye into the focal point.*

The image below pushes the bridge to the top of the picture area, creating a strong diagonal sweep with the riverside steps.

In the sketch next to it the artist has cropped in to the bridge to create a more intimate study – a good starting point for a more architectural approach.

The final sketch (top right) is more abstract in feel, stressing the curves, angles and shapes.

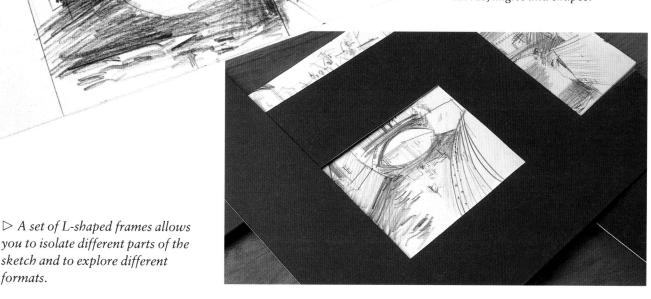

▷ *A set of L-shaped frames allows you to isolate different parts of the sketch and to explore different formats.*

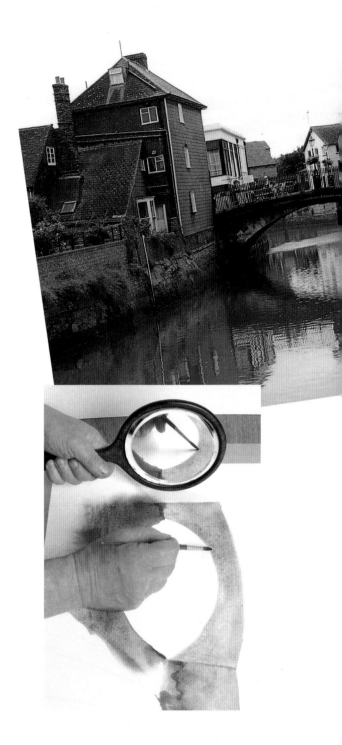

PROJECTS

BRIDGE AT LEWES

A bridge, water and some picturesque old buildings provide the artist with an inspiring subject for a painting. I have described on pages 18–19 some useful techniques for deciding which aspects of the subject to include in your painting.

The artist decided to make the bridge and its reflection the focal point of the composition. Having explored the composition in the sketches on pages 18–19 he found that the dramatic rhythms leading in from the right-hand edge drew the eye up and into the picture, over the bridge and around the reflection. The focal point is the watery area beneath the bridge, and here he has used a variety of marks, washes, lines, and scraped and scratched textures invented from the dappled water. The picture has a strong feeling of drama and movement. It opens its arms and embraces you, inviting you in.

The artist made a light drawing in pencil, then started to lay in blocks of colour, keeping the paint fresh and loose, constantly assessing the tones and colours. To create a good watercolour you must make accurate judgements, studying the subject intently, mixing washes of colour and comparing them with what you see before you and what is on the support, and you must achieve all this without losing the freshness of the surface and a sense of your original vision.

The drawing need not be very detailed, but it should be accurate. The important thing is to make sure that the buildings take up their correct position in space. Do this by drawing the spaces between objects – measuring one angle against another, one line against another, comparing, contrasting, measuring and redrawing until it is right. Check the drawing in a mirror. Because the reversed image is unfamiliar, any errors will jump out at you.

△ **2** *The artist started by laying in a few construction lines in pencil. Get these lines right and you have a sound foundation for your drawing. He drew the vertical of the building on the left and used this as a key against which to judge the other critical lines – the height and angles of the buildings above the bridge, for example, and the curves and angles of the river and wall on the right. The circle formed by the bridge and its reflection is the focal point of the painting. Here a hand-mirror is used to check the accuracy of the curve. Because a reflected image is reversed, it is unfamiliar and the eye is more critical.*

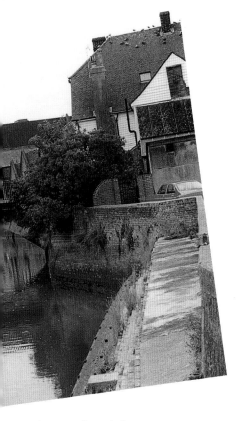

△ **1** *We found this picturesque scene in the car park of a small country town. You don't have to go way into the wilds to find suitable subjects; they are often just outside your back door, even if you live in an urban area.*

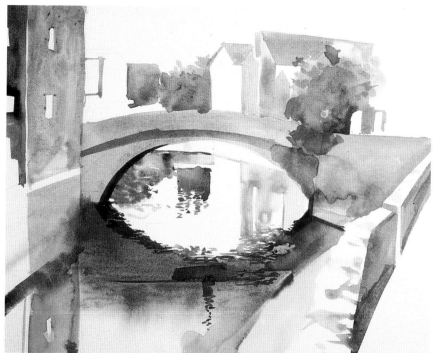

△ **3** *The artist worked quickly to get as much of the painting down as possible before the light changed. He used Prussian blue, black, Indian red and yellow ochre to lay in the water, the bridge and surrounding buildings, mixing greens for the foliage. At this stage try and keep the painting simple. Half-closing your eyes will help you to concentrate on the broad areas of light and dark, and colour, eliminating confusing detail.*

◁ **4** *Working broadly with a number 10 brush, the artist has established the main structures of the painting. Using the very tip of the brush, he then added details such as the ripples in the water.*

21

▽ 6 *The artist continued to develop the painting, working quickly to keep it fresh. Here he uses a quill to draw in crisp architectural details such as the railings. He uses dilute black ink. The quill gives the line a pleasing calligraphic quality. Don't be afraid to experiment with new materials and equipment, and learn to enjoy them.*

▷ 7 *The area of water framed by the bridge and the reflection below it draw the eye and form the focal point of the painting. Here the tip of a craft knife is used to scratch into the paper, breaking the surface to add texture.*

△ 5 *The painting was set aside for about ten minutes to allow it to dry. Watercolour behaves differently when it is used wet in wet and wet on dry. Flooding paint on to a wet support, or allowing one colour to flow into another, is exciting, but be careful not to overdo it. Allowing the painting to dry at intervals will let you retain the integrity of the areas of colour. You can modify the initial painting with washes of colour, or add detail wet on dry.*

Here the artist is developing an area to the left of the bridge. Notice the way the orange and green applied wet in wet have melded together, and the way the black line is opening out. Compare this with the crisp brown line above, applied wet on dry.

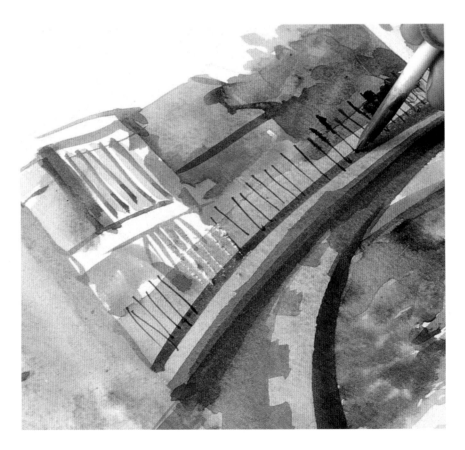

▷ 8 *This detail is important because it leads the eye into the composition. The artist has scratched with the blade, creating a symmetrical pattern. It has a mechanical feel, contrasting with the more fluid area behind it.*

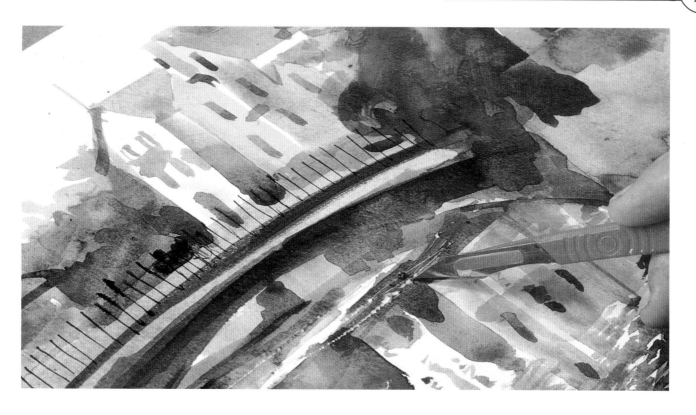

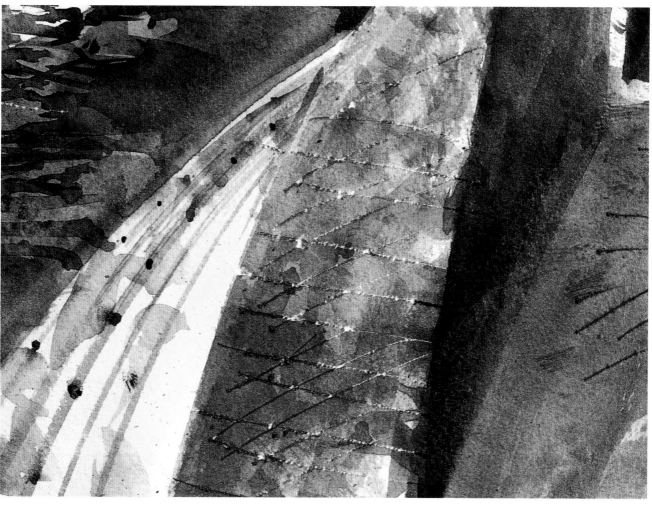

▽ **9** *The foliage of the tree is developed by adding blocks of mixed greens. Keep the forms simple and resist the temptation to overwork the image.*

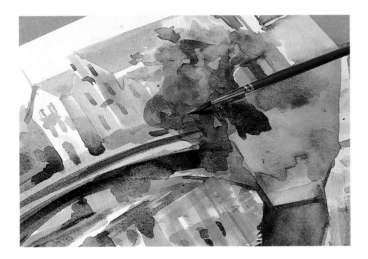

▷ **10** *The final painting depends for its success on the rigorous composition, which exploits dramatic rhythms, strong linear qualities and the drama of massed tones. You start one-third in from the right-hand side, at a point which more or less corresponds to the golden section – a proportion very approximately of one third to two thirds, traditionally found to be particularly satisfying. From here the wall surges up to meet the right-hand edge at a point one-third down from the top – on the golden section yet again. From here the line springs back to the left, across the bridge, till it meets the strong vertical of the building on the left and its reflection. There it is stopped, leaps to the top of the painting, then down to the bottom and across to the starting point again.*

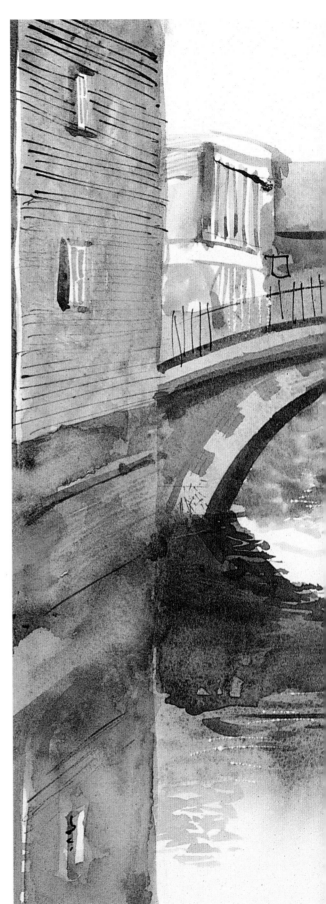

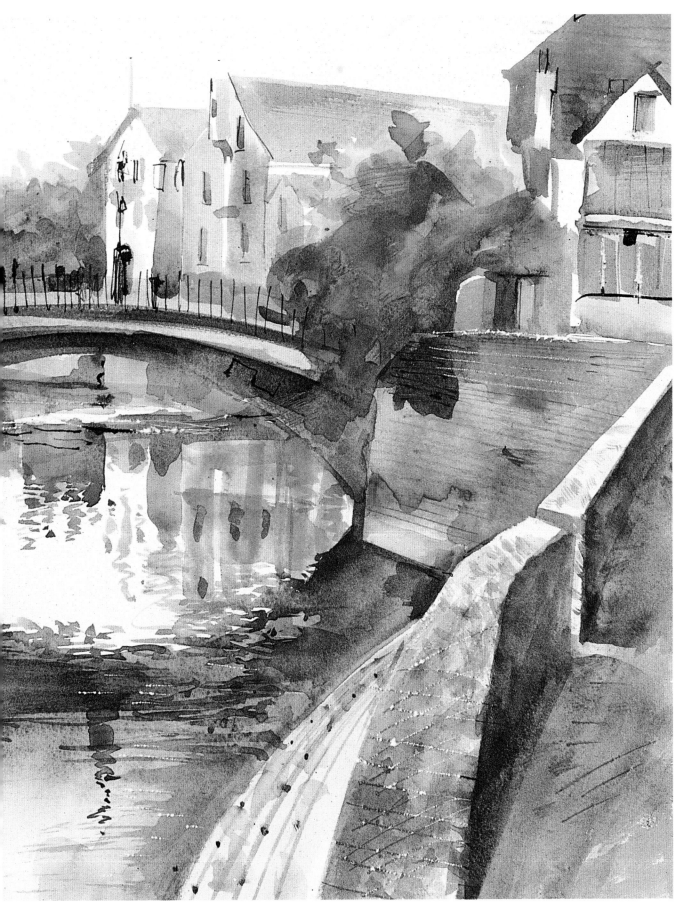

TECHNIQUES

LINEAR PERSPECTIVE

One of the problems which the landscape painter has to contend with is that of representing three-dimensional space on the two-dimensional surface of the support. Sometimes the artist will deliberately ignore the rules of linear perspective, or distort them in order to draw attention to the abstract or pattern-making qualities of a composition. But generally you want to create an illusion of depth, to trick the viewer into thinking that it would be possible to step through the frame of the painting and into three-dimensional space beyond it.

There are many ways in which artists achieve this feat, but the one which creates most anxiety in the bosoms of beginners is linear perspective. The trouble is that most explanations of linear perspective are supported by diagrams of amazing and confusing complexity.

One way to understand the concept of linear perspective is to imagine a piece of glass placed vertically in front of you, between you and the

▷ *In this picture the bases and the tops of the line of trees on the right, and the top and the base of the wall, as well as the edges of the road, all lie along perspective lines which converge at the same point, the vanishing point. To help you understand this, lay a sheet of tracing paper over the picture and draw in the perspective lines as shown in the diagram on the opposite page.*

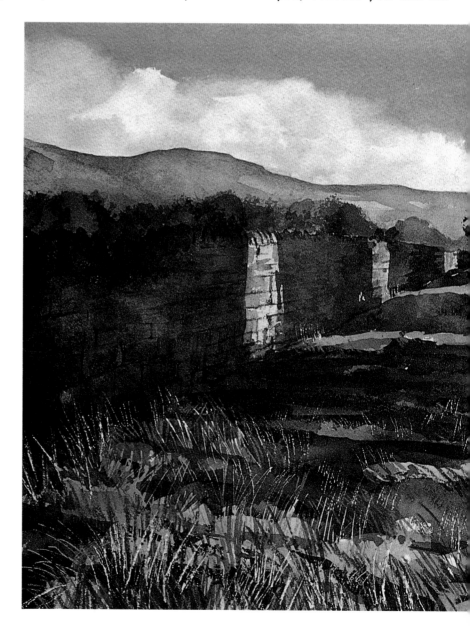

Perspective construction lines

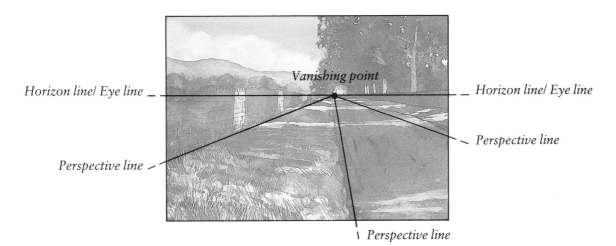

Horizon line/ Eye line — — *Horizon line/ Eye line*

Vanishing point

Perspective line

Perspective line

Perspective line

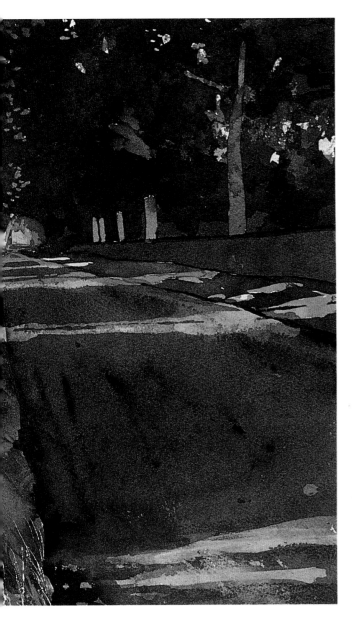

scene you are painting, at right angles to your line of vision. This is the picture plane, and it is a useful way of assessing the angles observed in the landscape (these can be checked against the horizontals and verticals of the frame).

Linear perspective starts by assuming a single viewing point – a point from which the artist, and the spectator, look towards the horizon. This is your eye level. The horizon line is at eye level and is established by taking an imaginary line from the eye to the horizon. You could draw it on the glass at your own eye level.

If you are seated, your eye level will be lower, and so too will the horizon. If you stand on a chair, your eye level will be higher, and so too will the horizon.

Vanishing points are the points on the horizon at which parallel horizonal lines appear to converge. Lines at right angles to the picture plane converge on the centre of vision, which is directly opposite the eye of the viewer.

Any plane parallel to the picture plane diminishes in size but retains its shape without distortion, so vertical lines remain vertical and horizontal lines parallel to the picture plane remain horizontal.

TECHNIQUES

SKETCHING

Sketching is a marvellous way to develop your drawing skills, and you'll find that professional artists draw constantly. But, more importantly, drawing sharpens your powers of observation. A good artist needs good technical skills, but the eye is even more important than the hand. If your work is to improve, you must learn to look at the world with the selective, discerning eye of an artist.

Drawing forces you to concentrate. With a pencil in your hand, it is difficult to fudge things. You have to make decisions about precisely where that tree is, for example; how big it is in comparison with the other tree; and even whether it should be in the drawing at all. Does it contribute to the composition, or would the image be more satisfying if the tree were moved, or shifted to another position? You can erase, scribble and redraw. It

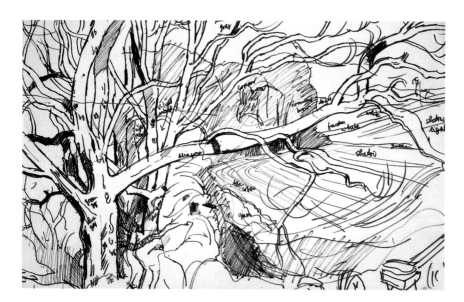

Pages from a sketchbook
These drawings are from Gordon Bennett's sketchbook. In the picture of the house by a bridge he is exploring the compositional possibilities of a scene. In others, such as those of the branches of a tree, he is analysing details.

doesn't matter, as long as you clarify your ideas and understand what you are seeing.

A sketchbook should be treated as a working tool, not as something precious. You can be uninhibited in your sketchbook – free to make mistakes, to explore and to experiment.

Use it to make drawings of scenes to be worked up into paintings later, and to record details – the texture of a tree trunk, for example, or the way an old gate hangs drunkenly off its hinges.

Written notes can provide a useful jog to the memory. On one of these sketches the artist has jotted the pigment colours which are closest to the colours he sees.

You can even sketch and hone up your observational skills without pencil and paper by forcing yourself to find exactly the right words to describe a colour or form. If you are out and about without your sketchbook, try talking your way round the scene. Describe the shape of a roof, the exact colours of slates and tiles, the way light and dark tones are massed on a tree. This is a difficult but wonderful way of forcing yourself to look and really 'see'.

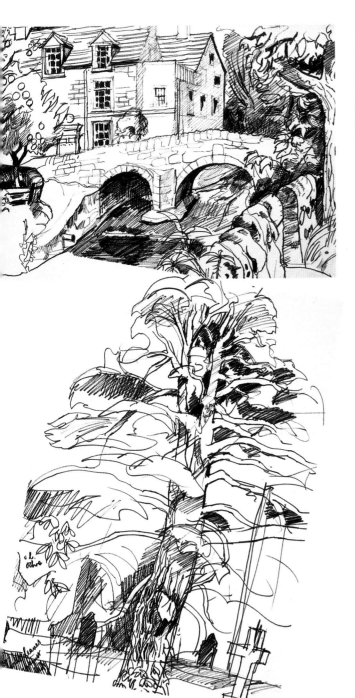

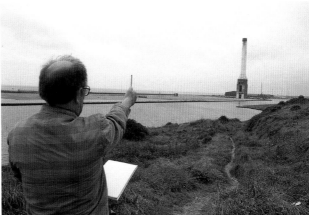

Measuring with a pencil
A pencil provides a simple means of estimating and comparing proportions, particularly vertical and horizontal distances, and angles. Select the object you want to use as a yardstick for your drawing. Hold the pencil out, making sure your arm is fully extended. Align the top of the pencil with the top of the object and use your finger to mark the bottom. This is the basic measurement against which all the others will be compared. Make sure the pencil is absolutely vertical. When estimating angles, start with the pencil horizontal and then rotate it until it lies along the line to be measured.

TECHNIQUES

CREATING TEXTURE

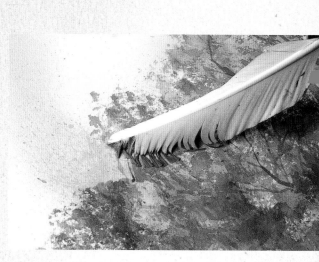

Watercolour is a wonderfully expressive medium, ideal for creating mood in painting – big threatening skies, sunlit summer days or mellow autumnal scenes. The watercolour artist must think on his or her feet, and be prepared to exploit the 'happy accidents' that are a characteristic of the medium.

Sometimes the paint dries quickly, creating hard edges where you didn't intend them; sometimes it takes for ever to dry. Colours bleed into one another, creating delicious swirls of colour which could never be planned. It is this potential lack of control that gives good watercolour an edgy excitement.

The medium can be blotted, splattered and scratched to create texture. The more you practise, the more you will learn and the more comfortable and confident you will feel.

Experiment with different papers. Notice the way the paint slips smoothly across hot-pressed paper. Use rough paper and see the way the colour pools in the recesses of the paper's surface, giving the wash a lively sparkle. Explore the possibilities of different brushes. Use the tip to lay long, fluid lines or to apply stipples. Use the entire head of the brush to lay bold, sweeping washes.

If you are new to watercolour, collect as much scrap paper as you can. Mix up a selection of colours in saucers and experiment. Use a brush slightly larger than you feel comfortable with. This will curb any tendency to fiddle. Don't worry if the paper cockles – these are experiments, though you could practise stretching paper. Drop one colour into another to see how the colours blend together. Use a hairdrier to dry the paper and see what happens when you paint wet on dry. Use the tip of the brush handle to scratch into the paint surface. Use a knife to break the paper. Go over the dry paint with pencil, pen, coloured pencils and crayon.

◁ *A feather is used in a dry-brush technique. Load the feather with colour, remove some of the colour with a tissue, then drag it lightly across the paper surface. It will create a broken, striated effect. You can also do this with a brush, removing excess paint with your fingers.*

◁ *Spattering is a useful technique which allows you to create a film of fine droplets of colour. Load an old toothbrush with colour. Hold the brush over the painting, masking off surrounding areas with paper, then draw your finger briskly across the surface of the brush to create a spray of droplets. You can also load a large watercolour brush and flick it for larger droplets.*

▷ *A sponge is useful for creating a range of textures. Collect small bits of natural and artificial sponge to make different effects. You can also use crumpled tissue. Sponge and tissue can be used to blot off excess colour.*

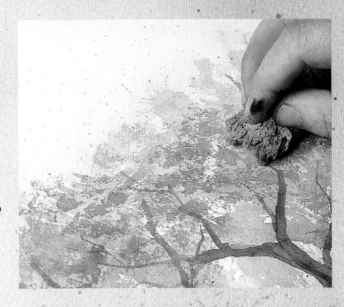

TECHNIQUES

RESIST

You can take advantage of the incompatibility of oily substances and water to create resists with candle wax, crayon and oil pastel. When water-colour is applied over a waxy or oily area, it forms droplets and tends to run off, because there is a mutual antipathy between oil and water. Some-times the droplets don't run off but dry on top of the oily passage, giving the surface a speckled effect.

White wax candle can be used to reserve the white of the paper and to introduce interesting textures. Apply the wax to the paper. It can be used descriptively to stand for light tones on a grassy area, the silvery bark of birch trees or pale reflections on the surface of a stream. It can also be used to add surface interest – in a rocky headland, for example.

As a painter you are constantly looking for ways of creating exact descriptions or equivalents, but your painting is also an entertainment. Wax resist can be used to produce surfaces which are rich, decorative or expressive.

Oil pastels can also be combined with watercolour, this time combining the resist quality with colour. On this page oil pastels have been used to introduce a linear element, to add texture and to draw some of the trees. In the painting 'The Old Power Station' on page 34, it has been used to introduce an abstract textural quality which implies the vegetation in the foreground rather than describing it exactly. By introducing texture in this area, the artist emphasizes the foreground, bringing it forward in comparison with the background. This aids the illusion of space in the painting.

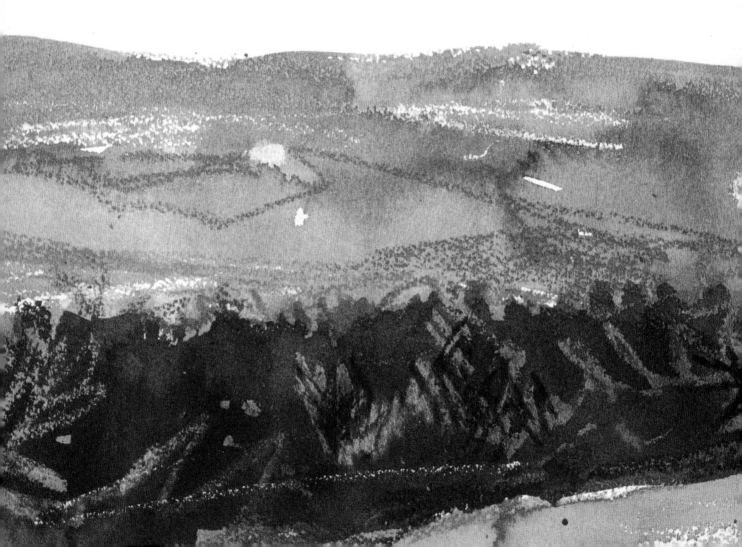

△ **1** Oil pastel and candle wax have been applied to the paper surface. A wash of colour is then added.

△ **2** Here the artist applies candle wax over dry colour. In this case the wax is used to reserve colour.

◁ **3** Another wash of colour is added. You can see very clearly the way in which the wax repels the paint.

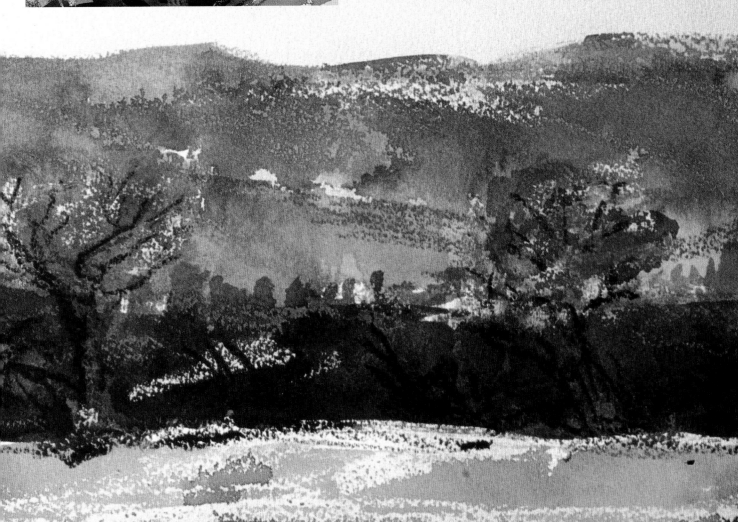

PROJECTS

THE OLD POWER STATION

This may not be your idea of landscape, but landscape isn't simply about romantically winding roads, babbling brooks, hump-backed bridges and sheep peacefully grazing. You can find absorbing material in the most unlikely spots.

Located on the outskirts of a coastal town, this chimney is all that remains after the demolition of a power station. Seen in silhouette against the sky, it had a majestic and brooding quality. The artist was captivated by the starkness and drama of this huge, monolithic structure, splendidly isolated in a barren wasteland.

The composition was carefully contrived to capture these qualities. The tall, 'portrait' format leads the eye up the picture area, drawing it towards the chimney. Scale is important, and the picture calls attention to the way the chimney dwarfs the ships, factories and warehouses around it.

The underlying geometry of the picture is important. The chimney divides the picture more or less on the golden section; the path in the foreground is deliberately offset to avoid the chimney and path together splitting the painting into two.

Contrast is a useful compositional device. The reflection of the chimney in the water carries a strong vertical down into the lower half of the painting. The path echoes the shape and size of the chimney, but its natural feel is contrasted with the man-made, constructed nature of the chimney. In the top half of the painting the wharves and buildings are described accurately with a remote detachment, while in the lower area the artist has used a variety of media to produce highly textured passages which have an expressive and abstract quality.

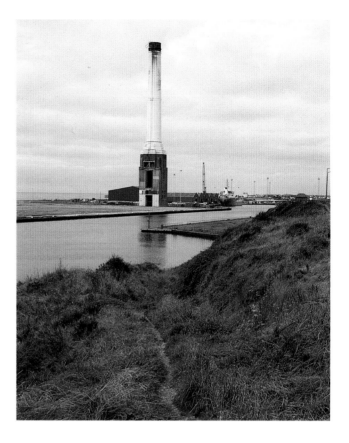

△ **1** *Not a candidate for the 'chocolate-box' school of landscape painting, this remnant of industrial architecture inspired an imaginative and satisfying image.*

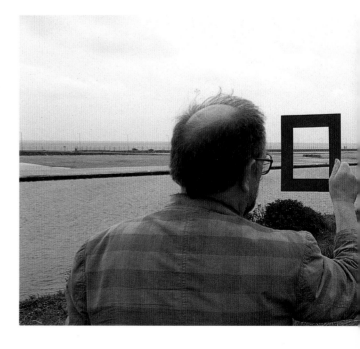

△ **2** *The artist used a viewfinder to frame the image. He decided that a vertical or 'portrait' format would enhance the drama of the scene.*

◁ **3** *The artist made a drawing to explore the possibilities of the composition.*

▽ **4** *The artist used colour pencil to record the colour and tonal relationships within the composition. The sketch performs two functions – it is both an exploration of the subject and a record which will be useful if he wants to continue in the studio.*

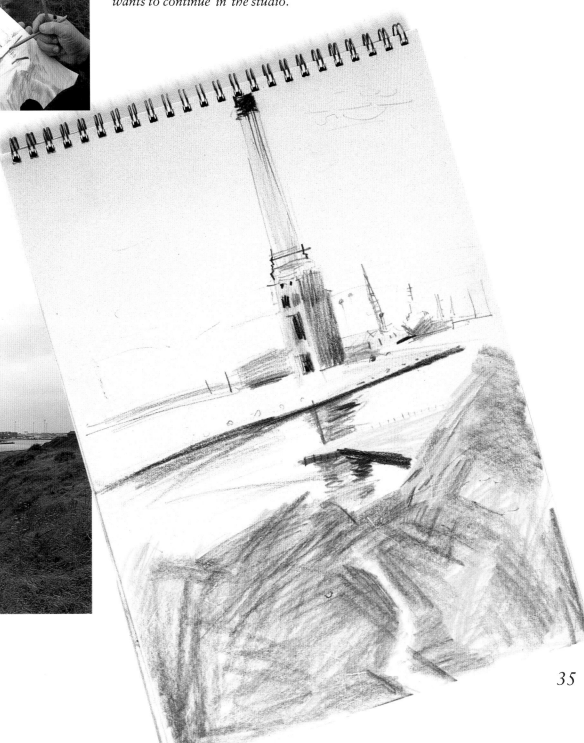

△ 5 *The chimney will be the lightest area of the painting. The artist reserves it with masking tape, and by cutting the shape of the chimney with a knife is able to capture its crisp, man-made silhouette.*

△ 6 *To make the painting more dramatic and interesting, the artist developed the foreground in a rather abstract way, using oil pastels to create textures. These textured passages perform several functions. They describe the vegetation without painting every leaf and blade of grass, and provide a decorative surface which is entertaining. They also enhance the sense of space in the painting by bringing the foreground forward.*

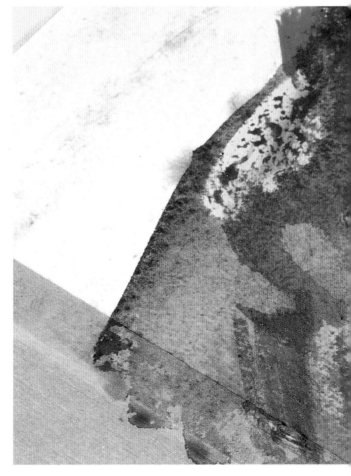

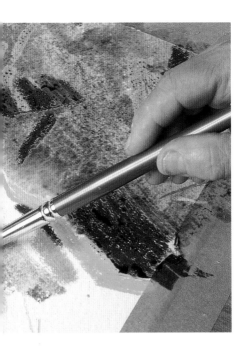

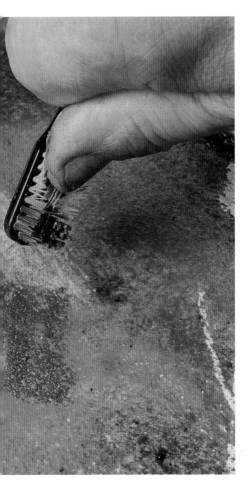

◁ 7 *Watercolour is flooded over the oil pastel, which acts as a resist.*

▽ 9 *The blue of the sky was flooded in, using a wet-in-wet technique. To do this the artist turned the painting upside down, loaded a brush with water and dampened the sky area, working carefully along the skyline. Then he tipped up the board – still upside down – loaded a brush with cobalt blue and laid a wash, working backwards and forwards across the paper.*

▽ 8 *Colour is spattered on to the painting, adding more texture to the foreground.*

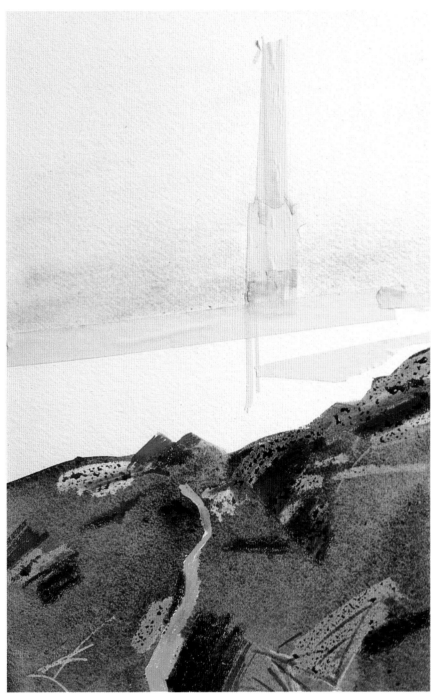

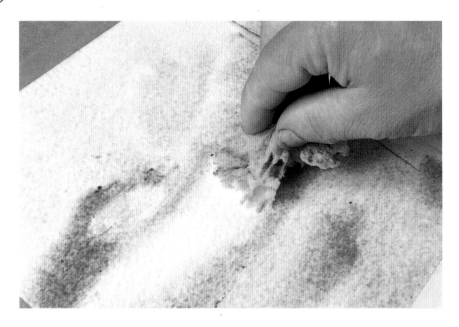

◁ **10** *Another wash of colour is added to the sky, then colour is blotted off with a sponge to create the variegated appearance of a cloudy sky.*

▷ **11** *The masking tape is removed to reveal the neat white area beneath.*

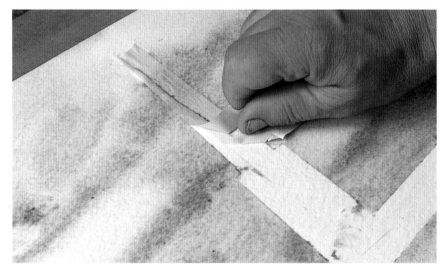

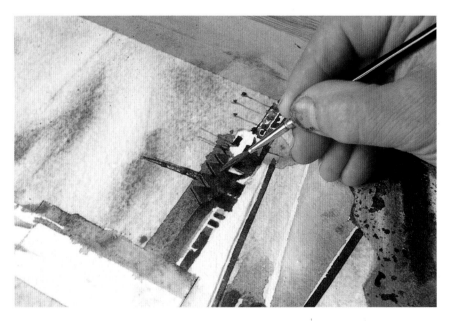

◁ **12** *The artist sharpens up the detailing in the middle distance. He develops the cranes, buildings and factory roofs, using close tones to ensure that they take up their correct position in space. If he used bright colours or sharp contrasts, this area would move towards the front of the picture plane, destroying the illusion of recession. He uses warm and cool colours, but the reds are relatively cool, because warm colours are inclined to advance. If he had used hot reds for the roofs, they would have jumped forward.*

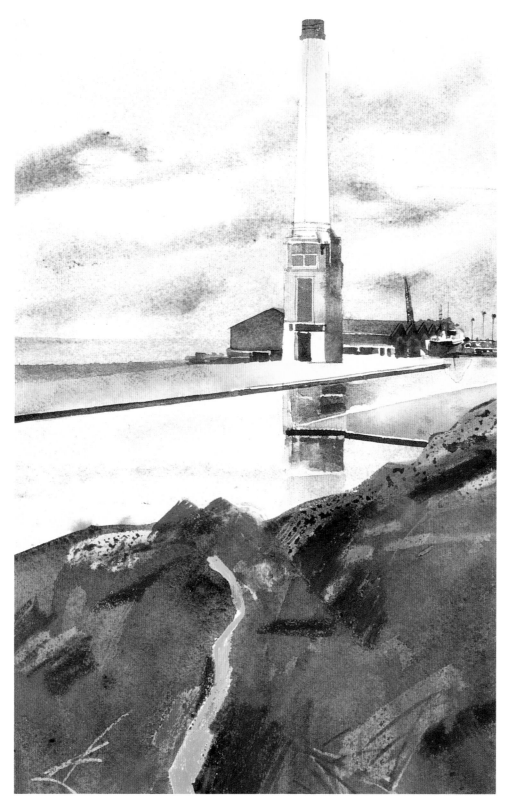

△ **13** To complete the painting, the artist added a touch of yellow ochre to the top of the chimney stack, so that it becomes ochre against blue at the top and white against blue lower down. The local colour – that is, the 'actual colour' of a surface rather than the 'perceived colour' – of the chimney is a creamy yellow, but if it was rendered in a single colour it would appear flat and insubstantial.

The pathway is rendered as a jagged gash of bright colour which forces the eye up into the upper part of the painting, which is restrained and cool.

PROJECTS

BRIDGE AT ALFRISTON

The artist worked on this painting over two sessions on different days. If you don't manage to complete a painting in one session – perhaps the light has changed or the weather is unkind – you can return to it later. Make sure, though, that you choose the same time of day, or otherwise the light will be different. If you have sketches or even a photograph, you can develop the painting in the studio, returning to the location to refresh your memory and add the finishing touches.

A bridge provides the painter with some interesting compositional possibilities and the opportunity to play off the hard edges of a man-made structure against the soft, sinuous forms of nature. In the study of a bridge on page 20 the artist focused on the view through the bridge, working with the curves of the structure and its reflection in the water, creating an image which is essentially romantic.

The view of the bridge here explores a different quality – the way the wide sweep of the road invites you into the painting and dips over the bridge, leaving a query about what you might find on the other side. Another trigger point was the complex rhythmic pattern of the man-made fencing leading up to the bridge, the geometry of the fencing contrasting with the massed foliage of the trees beyond but linked to it by the natural, weathered timber from which it is constructed. The artist has managed to express the individual qualities of the different parts – the fence posts, the wall, the branches and the tree trunks – and, at the same time, integrate them beautifully.

An interesting problem for the artist to contend with – one that you will encounter too – was how to render the metalled surface of the road. Painting 'nothing', whether it is a flat road, a flat field or a large expanse of water, is a real challenge. Remember

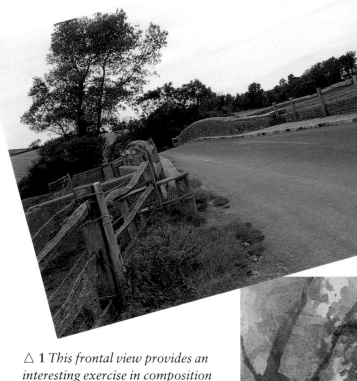

△ 1 *This frontal view provides an interesting exercise in composition and perspective. Compare this with the project on page 20.*

▷ 3 *The support is a beautiful, slightly tinted handmade paper. The artist indicated the broad areas of the painting lightly in pencil. He laid in discrete areas of colour, working over the whole of the painting. The massed foliage in the background had to be handled carefully, avoiding anything too explicit which would bring that area forward. He looked for the clumpings of foliage on individual boughs, branches and twigs, and laid down these areas. He let the painting dry in the sun and then overlaid more colour, trying to find a visual equivalent for the trees. He mixed a huge variety of greens, creating others by overlaying one colour with another.*

that anything horizontal and parallel to the sky reflects light from above and tends to be light, in contrast with vertical surfaces like trees and bushes, which tend to be dark. You need to look at the 'empty' passage as an important compositional element, a shape against other shapes and an area of colour and tone. View the picture through half-closed eyes to see if the separate elements knit together satisfactorily. If they don't, go back to the subject to see if you can find any clues there. And don't be afraid to put things in or leave them out if the composition demands it. Make the painting your own.

◁ **2** *The artist returned to the painting for a second session. Working without an easel, he uses the fence posts to balance his equipment.*

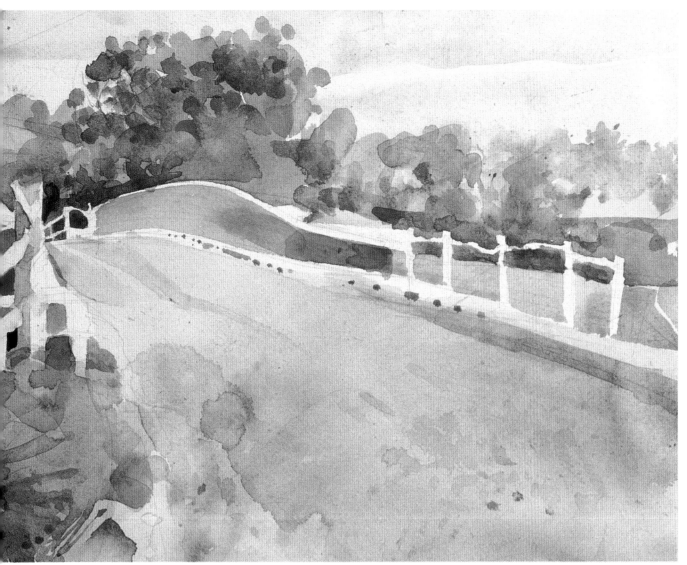

▽ **4** *The tones of the fence were laid in with great care. This is an important element in the design, leading the eye into the composition and across the bridge. Darks were added, mixed from raw umber and cobalt so as to retain a transparent feel.*

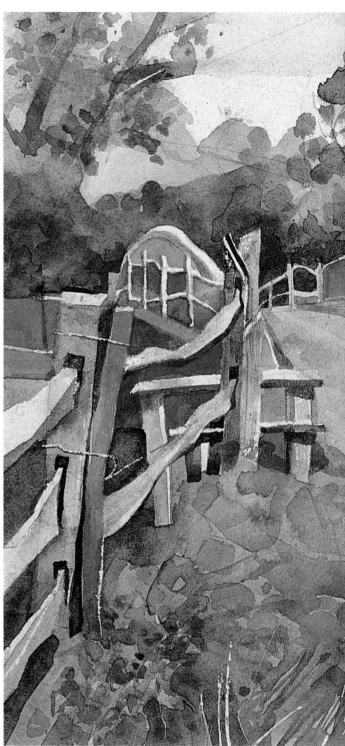

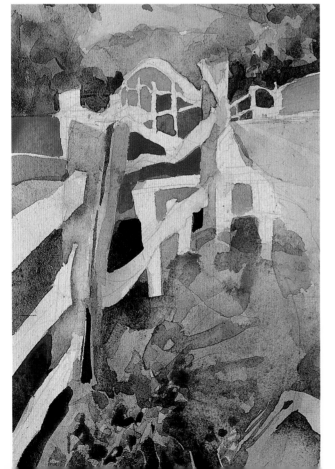

◁ **5** *Using a wash of Hooker's green, the artist adds more detail to the vegetation on the verge. The paint is laid wet on dry and allowed to dry with crisp edges, which describe the complex forms of grasses and other plants. By adding more detail to this area you will* bring it forward on to th[e] *plane, creating a sense o[f]* You have to judge just h[ow] detail to add – enough to convincing illusion with[out] distracting attention fro[m] the painting.

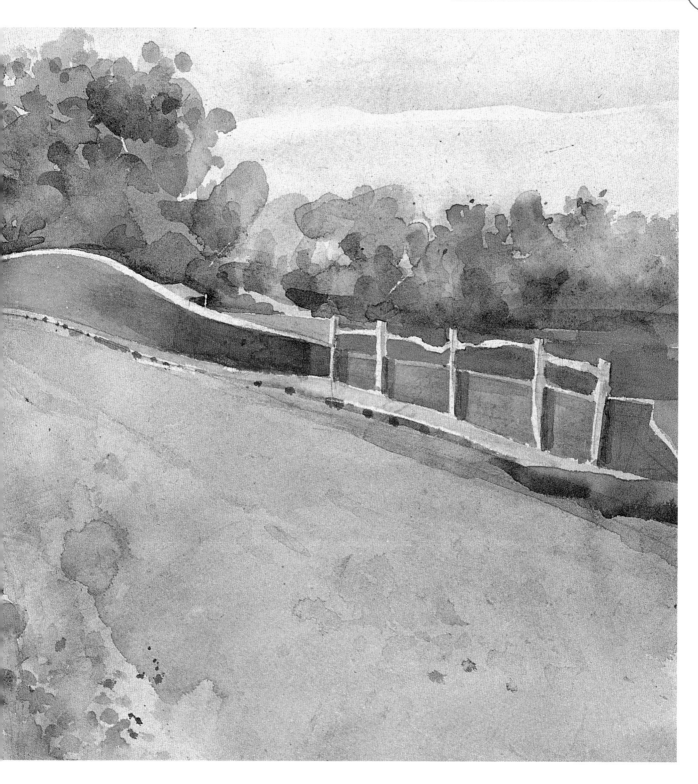

△ 6 Some more washes were laid on to develop the trees and foliage.

Warm colours, sharp tonal contrasts and bright colours tend to advance, while cool colours recede, so the artist puts the warmer and brighter colours in the foreground – lilacs, purples and brighter blues – to create a sense of recession. As the road moves towards the crest of the bridge, the colours he uses are pale blues and bluey greens.

A dry brush was used to add detail to the stile and foreground timbers. Finally, a quill pen, charged with a mixed neutral tone, was used to draw the wire attaching the foreground posts.

43

PAINTING SKIES

A difficulty which confronts the novice watercolourist is rendering skies, and particularly cloudy skies. It is especially difficult when you are painting directly from nature. With bewildering haste one beautiful arrangement of clouds succeeds another.

An early lesson to learn is that clouds are three-dimensional structures, with tops and undersides which reflect light in different ways. Start by making some rapid drawings on a cloudy day – use pencil or charcoal. Half-close your eyes so that you can focus on the light and dark tones, and draw what you see.

The great British landscape painter John Constable (1776–1837) painted skies time and time again, working in oil on heavy paper. In 1821 he talks about having 'done a good deal of skying'. For Constable, the 'sky is the "source of light" in nature

△ **1** *Using a wash of cobalt blue and a large brush, the artist lays a wash on to damp paper.*

△ **2** *Here the artist uses a damp sponge to wet the paper in the cloud area and to take off colour at the edge of the blue area.*

◁ **3** *A very pale yellow is flooded in to warm the tops of the clouds.*

44

– and governs every thing'.

The sky should not be thought of as separate from the earth beneath it. Light and colour bounce back and forth between the two, modified in their passage through the atmosphere.

Skies are laid on, using wet-in-wet techniques. You will need to make up a wash of colour. Make sure you mix enough – if you run out half-way through, the paint will dry as you are mixing up more colour, creating a hard edge where you don't want it.

The secret of dealing with skies is speed, and here watercolour comes into its own. Damp the paper with a sponge or a large brush, load a wash brush with colour and lay a wash, working briskly. If you make the sky paler towards the horizon you will create a sense of distance. Study the sky carefully. It is often suffused with a hint of warm yellow or ochre where it meets land or sea.

Clouds can be created by taking off colour with a damp sponge. If you are working with gouache or body colour, you can bleed white paint in to create cloudy effects. Don't forget to add darker tones on the underside of the cloud formations.

◁ 4 *A dilute mixture of black is touched into the underside of the clouds, where it bleeds into the lighter areas.*

▽ 5 *The subtle tones, together with the combination of soft and crisp edges, and bright white of the paper create an interesting and convincing sky.*

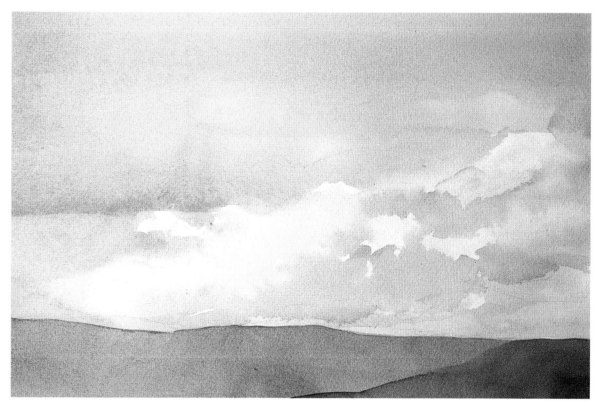

TECHNIQUES

MASKING

The white of the paper is important in pure watercolour. It gives you whites, light tones and highlights. In paintings where the local colour is white – a white building, for example, or the chalk figure in the next project – whites are particularly important. The effort of remembering not to stray into those areas can be very restricting, and prevent you working freely with the gestural marks and experimental textures which give watercolour character. This is where masking fluid comes into its own.

It is a milky liquid which can be applied to paper with a pen or a brush. It dries to a thin, rubbery film which protects the painting while you work. When the painting is finished, or when you want to develop the masked area further, remove the mask by rubbing the area gently with your fingertips or an eraser. The mask comes off as a thin film and rubbery crumbs, revealing the clean white paper beneath.

Masked areas have a special crisp edge which lends itself to certain applications – to rendering buildings, fence posts and other structures, for example. Sometimes, however, you don't want the paper to stay brilliant white and there is no reason why you shouldn't work over the masked area. In the example on this page, the artist has used the masking fluid in a variety of ways. It has been applied with the tip of a fine brush to reserve the delicate tracery of the flower stems, while a larger brush has been used to 'paint' the silhouettes of the flower heads. In some areas the mask has been applied over a previously painted area to reserve a

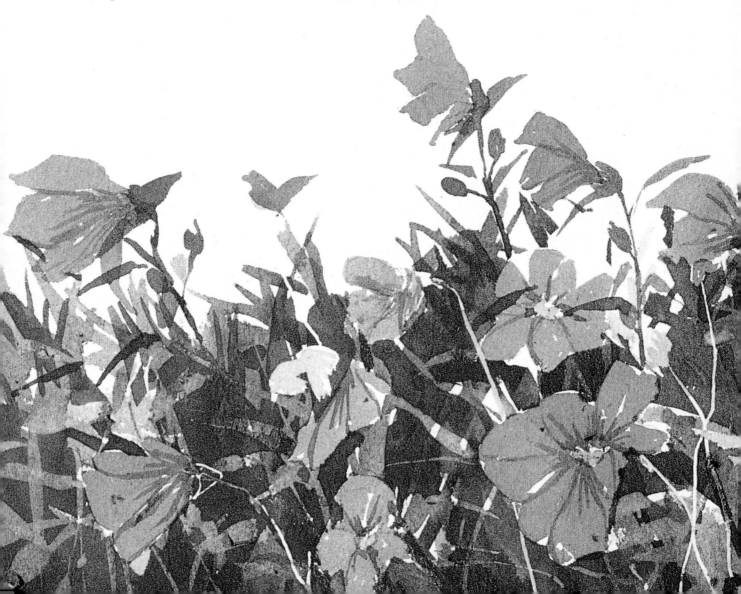

shape in a light tone, allowing the artist to work freely in a darker tone which will ultimately define the masked form – the mask allows him to paint the 'negative' of a flower stem.

The mask was removed and the masked areas treated in a variety of ways. The white of the paper has been left to stand for stems, but the flower heads have been painted in a magenta mix, in the crisp masked shapes.

Masking fluid is generally available in two forms. One is pure white, but it is a bit difficult to see against the white of the paper. A slightly creamy version is easier to see, but it can stain certain papers if it is left on for too long.

Masking fluid can be used in a precise way to mask forms accurately. It can also be used more freely – splashed on, dashed, daubed and dotted to create interesting textures. You could, for example, splatter masking fluid on to a watery area to create sparkling highlights.

▷ 2 The mask can be removed by rubbing gently with your fingertips. Here you can see how thin the film is.

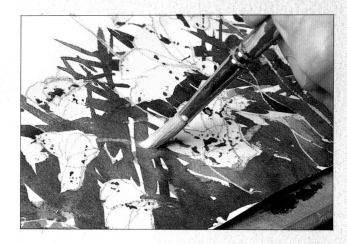

△ 1 The bold shapes of the flowers and the delicate lines of the stems have been masked with creamy fluid. Here a masked line is applied over green foliage.

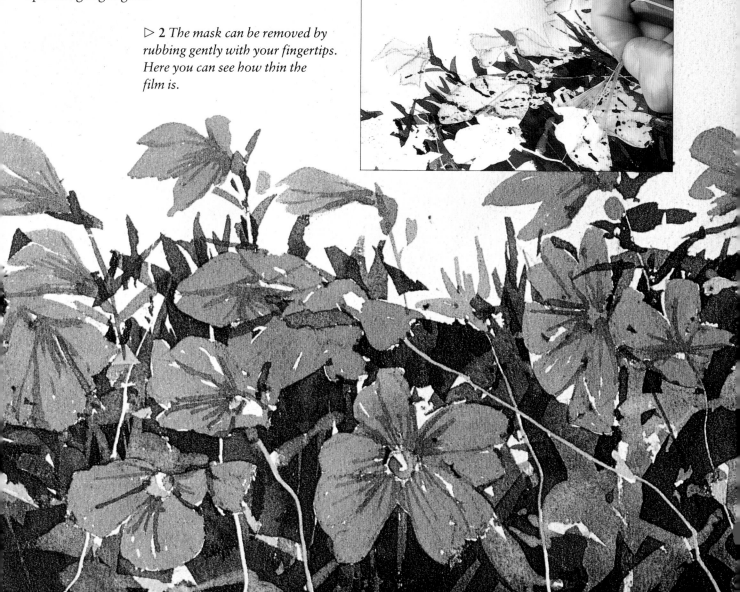

THE LONG MAN OF WILMINGTON

The Long Man of Wilmington is a giant figure, some 227 feet (70 m) tall, cut into the turf of Windover Hill in the chalk downlands of southern England. Speculation about its origins and uses abounds, and although there are suggestions that it may date back to the Bronze Age, the first recorded reference to it is in 1779. Chalk figures need regular maintenance to prevent the short chalk turf covering over the outlines, and in 1969 the Long Man of Wilmington was picked out with 700 white concrete blocks to fix it permanently.

The rolling downlands and the strange iconic figure presented the artist with an engaging and mysterious subject. The challenge was to integrate the chalk figure into the landscape, so that it became a significant part of the composition without dominating it. A 'portrait' of the figure would have had less impact.

The figure was placed slightly left of centre and the picture area divided into three bands – the sliver of sky at the top, a broad band of green chalk downland beneath it and, in the foreground, the warm ochry tones of the stubble field.

The rows of stubble perform several particularly useful functions. The converging lines lead the eye into the composition; they also contribute to an illusion of space, suggesting travel from the picture plane back towards the downs in the middle distance.

The chalk downland had a distinctly warm quality. Perceiving this, and realizing that the green would be recessive, the artist laid a wash of warm, pinky red. When this was dry, he washed it with green. The play of red against green, warm against cool, adds interest to the downland area and pulls it forward. Red and green are a complementary pair,

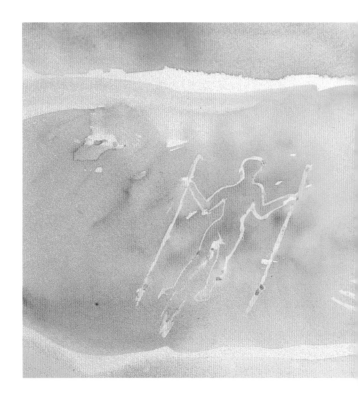

△ **1** *This ancient figure on the scarp of a chalk valley provided the artist with an entrancing subject.*

▽ **2** *Using a pen, the artist drew the outline of the Long Man in masking fluid. He also masked off the areas where the exposed chalk shows through the turf sward. Working quickly, he laid a wash of blue for the sky, rosy red for the hillside, and ochre for the stubble field.*

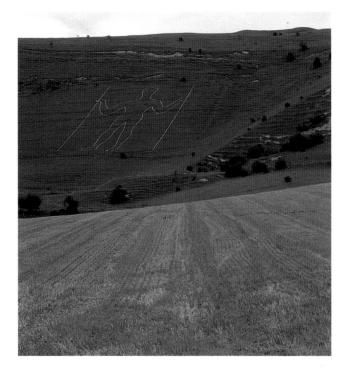

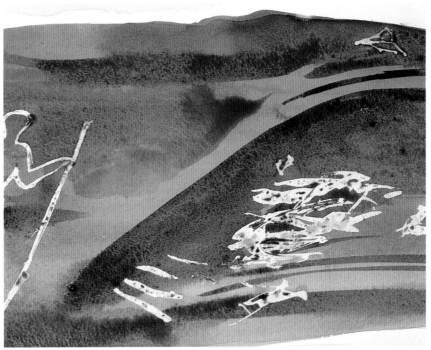

▽ **4** To *create a darker green, he added blue to the Hooker's green. He used this to define the forms on the hillside, adding the colour wet on dry.*

△ **3** *The artist chose a middle green – Hooker's green – for the hillside. He mixed the wash in the lid of his paintbox.*

so the underlying red gives zest to the green.

If you look at the photograph of the subject, you'll see that the pinkish earth and ochre stubble are set off by the bright acidic green of the grass springing up in the furrows. The artist made something of this, emphasizing the contrast and exaggerating the green rhythms which lead the eye into the picture.

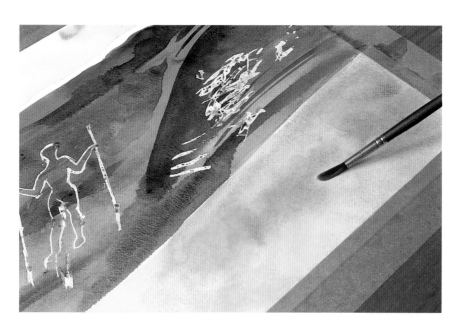

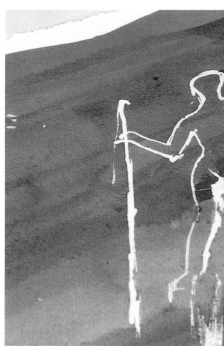

△ 5 *The artist added more rich colour in the foreground to add interest to the area and bring it forward. The colours used are burnt sienna, cadmium red and chrome yellow deep.*

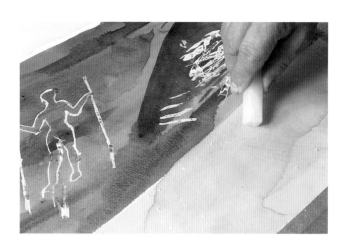

△ 6 *A wax resist is used to create the furrows in the stubble field. Using a candle, the artist 'draws' the furrows.*

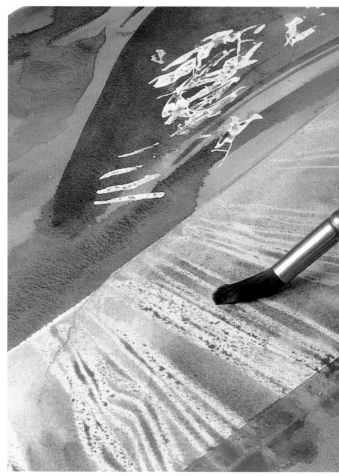

△ 7 *Hooker's green is flooded on to the foreground area, where the wax resist repels the watercolour.*

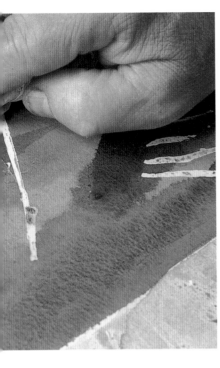

◁ 8 *The masking fluid is removed by rubbing it gently with a tissue.*

▽ 9 *Warming up the foreground and re-emphasizing the rhythms of the lines of stubble create a sense of travel into the middle distance, drawing the eye to the chalk figure in its downland home.*

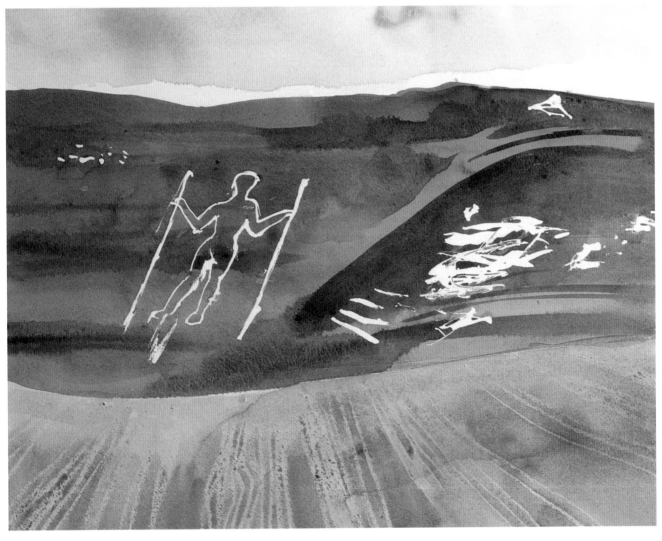

▽ **10** *Texture and detail are added to the grassy areas. The basic green is modified by the addition of yellow, to create a warmer tone, and blue, to create a darker tone. Using the dark tone, the artist 'draws' in the terraces on the hillside. Try not to be too literal at this stage – find an equivalent for the forms. Here, for example, the stripes of dark colour describe the terraces but also create an interesting decorative pattern.*

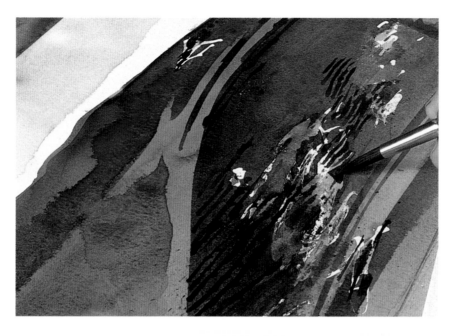

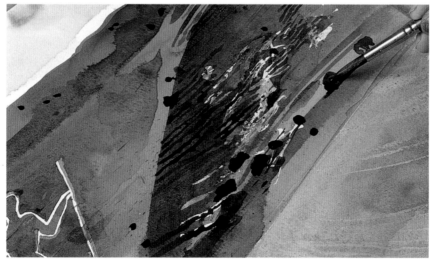

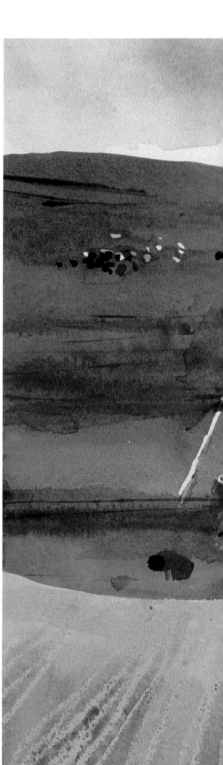

△ **11** *The scrubby bushes scattered over the hillside are touched in with the tip of the brush.*

▽ **12** *The final painting is an atmospheric evocation of the scene. It describes this particular view so that it would be recognizable to anyone who knew it, but it is not a photographically realistic interpretation. The artist has opened himself to the landscape, to the mood and also to the possibilities of the materials. It is important that you allow the materials to work for you, so that you in turn can respond to them, taking the painting in new and interesting directions.*

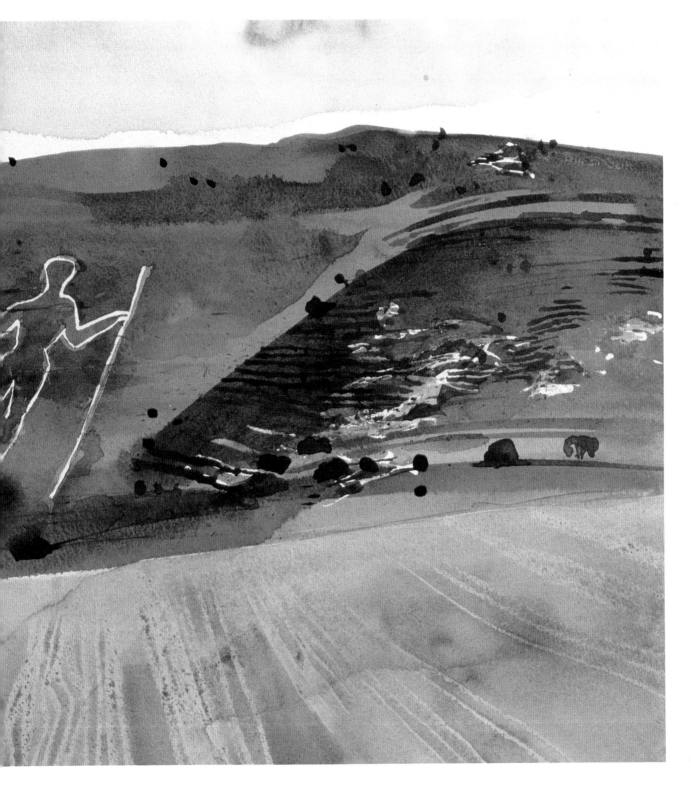

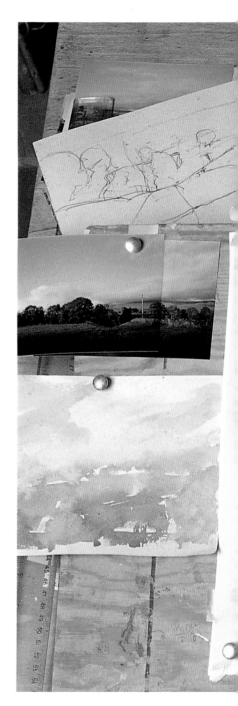

Working in the studio

Working in the studio is a very different process to working out of doors. When you paint directly from the subject, you generally aim to complete a painting in one sitting, recording your impression of the scene rapidly. You are keyed up, focused and concentrated, aware of even the slightest change in the light, making compromises all along, the limited time available forcing you to act decisively.

In the studio you can work in a more considered way, allowing the picture to evolve slowly. You can take it so far and then set it aside, living with it for a while before you work on it again. In many ways the artist has more control when working in the studio. Away from the subject, you lose the immediacy of the direct response but you can develop your own themes, impose your ideas and take time to let the painting evolve.

You will need good reference material. There is nothing to replace sketches and drawings made on the spot – these force you really to look at the scene and analyse it, to store it away in your memory. Colour sketches, colour notes and photographs will all prove invaluable when you return to the studio.

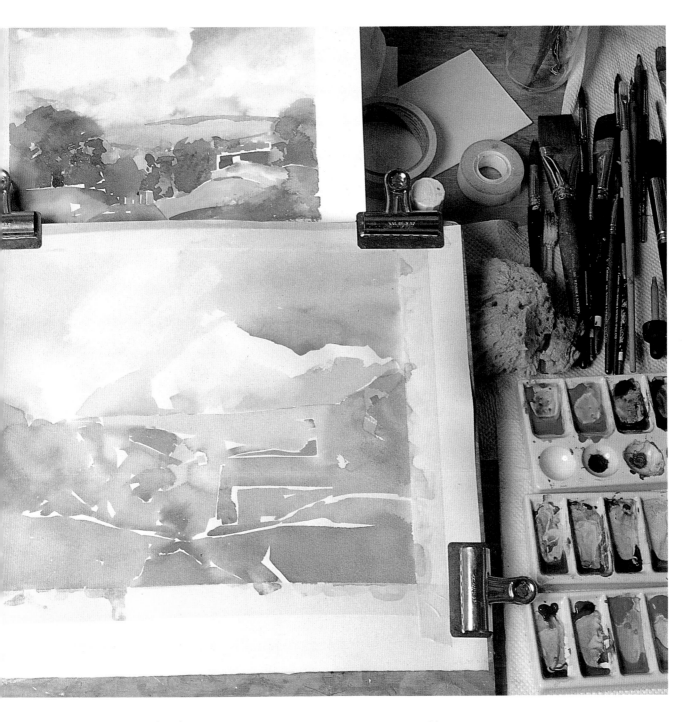

Pencil sketches, colour sketches, watercolours and photographs collected on location to be developed in the studio. On the right is a collection of ceramic palettes. In the studio you inevitably have more space for mixing colour, so it is easy to work on a large scale.

BLUE CRANE

More than anything this painting is about colour – the wonderful burnt orange of the piles of sand and gravel sizzling against the cerulean blue of the crane. This scene was found in a dockyard area, not far from the location of the power station which was the subject of the painting on page 34. Again, an unlikely urban landscape has thrown up an exciting subject.

The artist played visual games with the colour, pushing the natural colours towards the true complementary relationships. Complementary colours occupy positions on opposite sides of the colour wheel and when placed side by side they enhance each other, setting up a lively resonance.

The other theme developed in the composition is the geometry of forms, and the contrast between man-made and natural ones. The shapes of the buildings were carefully plotted against horizontal references, using a plumb line. The artist worked precisely, ruling lines to create crisp edges, masking others with tape – the bird-like profile of the crane, for example. These geometric shapes contrast with the more natural forms of the piles of sand, but even these have the sculpted appearance of wind-blown sand dunes. Rendered in exaggerated light and dark tones, they have a surreal, fantastical quality.

The artist used a variety of techniques, flooding glorious oranges into wet paper for the dunes but working in a more controlled and precise way as the painting progressed.

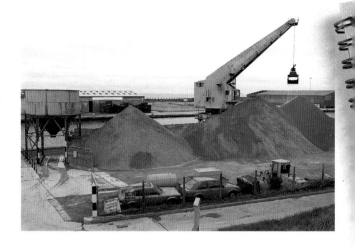

△ 1 *The blue crane set against the ochre of the pile of sand gave the artist the motif for this painting.*

▷ 2 *In this pencil sketch the artist recorded the scene and sorted the information for later use. Notice the detail of the jib of the crane at the bottom of the page.*

△ 3 *In the studio the artist 'drew' the shapes of the sand piles in water, flooding a range of golden tones on to the damp paper.*

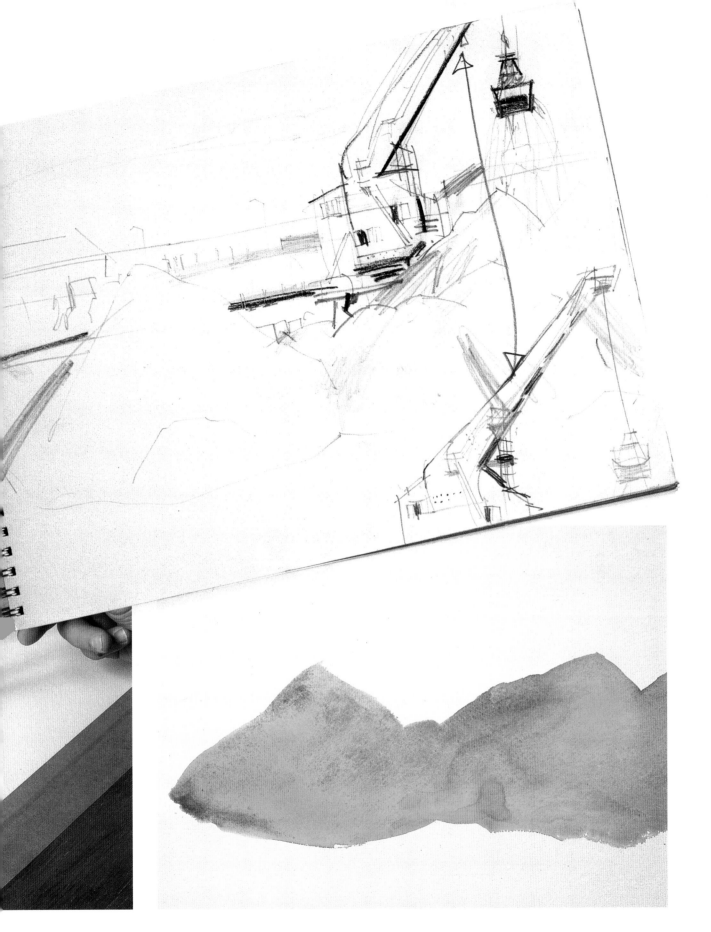

△ ▷ **4** At this stage the painting consisted of a series of
orange pyramids. The work itself suggested the way the
artist should go, emphasizing the brilliant colours.

△ 5 *The artist laid in the dark tones, using a rich, warm colour. He worked with a hairdrier to speed up the drying process and also to cause the colour to puddle and dry with a hard, crisp edge.*

◁ 6 *Working in the studio allows you progress in a more deliberate, controlled and experimental way. Here the artist uses the edge of a piece of card to add linear detail and interesting texture to the sand.*

▷ 7 *The outline of the crane is masked with tape to give it a crisp, hard edge.*

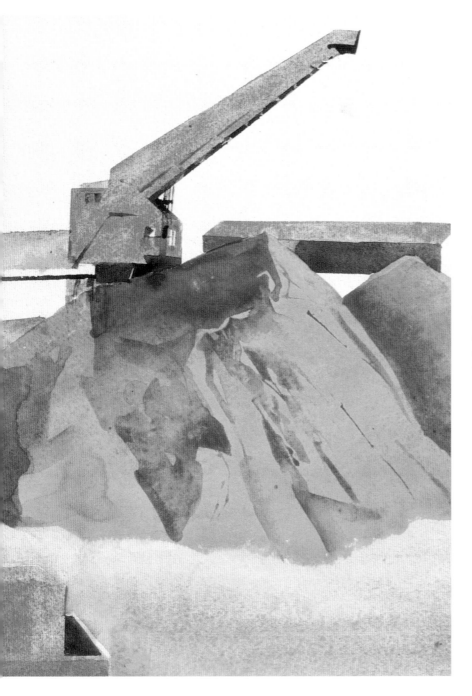

◁ 8 *The forms are geometric. They are rendered with crisp edges, which give them an abstract quality, but they are nevertheless descriptive and realistically portrayed.*

9 *The artist rendered the image with accurate detail, returning to the scene to collect further information. The complementary theme is carried on at the top of the painting where a startling red shape is set against some doors in green to echo the blue–orange relationship. Elsewhere the colours are muted – neutrals, greys, reduced yellows and drab greens.*

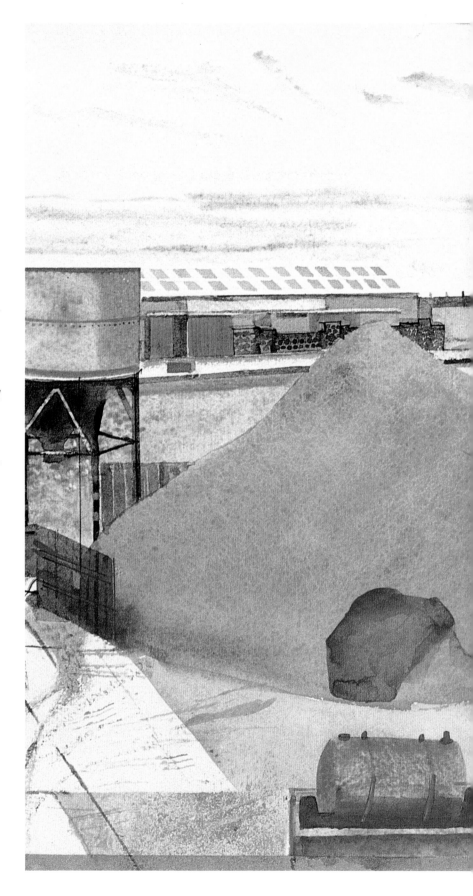

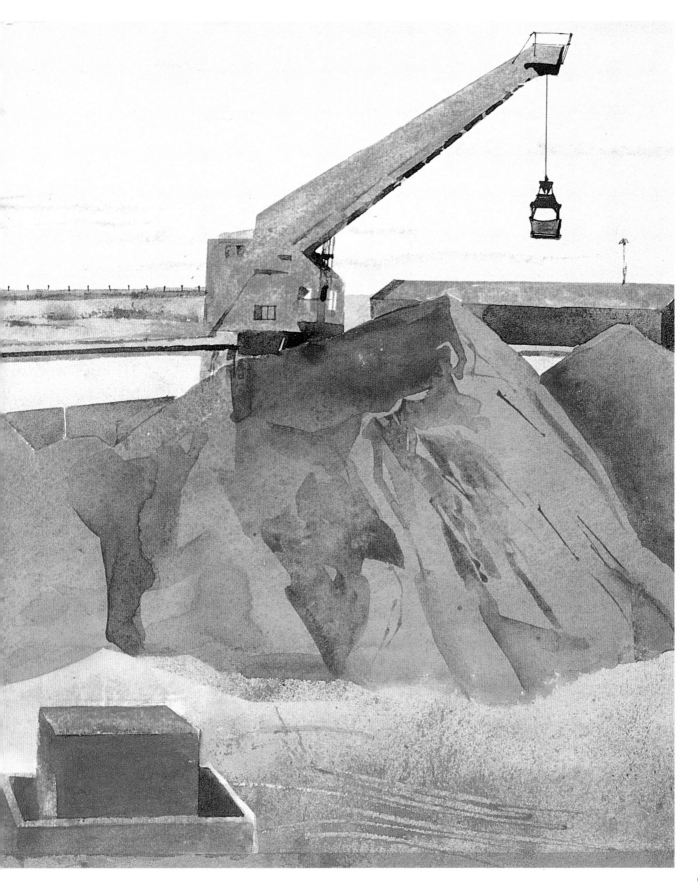

PROJECTS

JACK AND JILL

This pair of windmills, named after the characters in a nursery rhyme, stands sentinel on the chalk downs which loop along the south coast of England. Jill, the white post mill, was built in 1821 in Brighton and contemporary prints show it being drawn across the downs by huge teams of oxen. Post mills are built on a single vertical post so that the whole structure can be turned to face the prevailing wind. Later it was realized that the whole building need not rotate, and tower mills such as Jack were built. These had rotating caps to which the sails were fixed. Jack, the brick tower mill, was built on site in 1896, and both Jack and Jill worked until 1907.

The artist visited the site towards the end of the day. The sky was threatening and he was buffeted by squally winds. But it was too good an opportunity to miss, so he made a quick sketch using conté pencil and watercolour pencil. As he worked, the weather broke and it began to rain. The spatters of raindrops caused the watercolour and the conté pencils to dissolve and bleed, the wet conté in particular creating a very dramatic effect.

The artist worked up the image in the studio and returned to the location the following day to add more detail. It was extremely windy – the conditions were, if anything, even more difficult than they had been on the previous day. He was surprised by the number of changes that had taken place. The white post mill had moved round, so he had to work from several locations in order to reconstruct the original view. The sky, too, was entirely different. He laid in large washes in warm blues with a little crimson, but still felt that a more atmospheric effect was required. He turned and found a magnificent lowering sky behind him, with scudding clouds. He didn't paint that sky, but carried the memory of it in his head so that it influenced the sky in his painting.

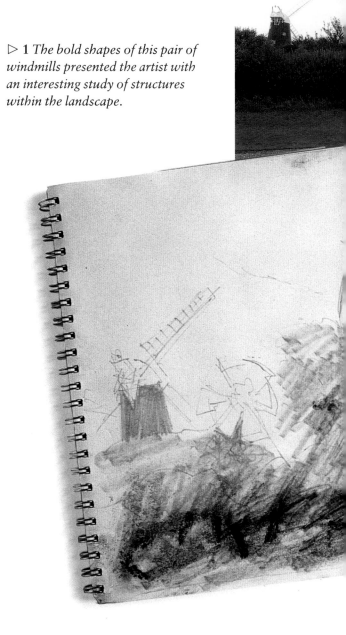

▷ **1** *The bold shapes of this pair of windmills presented the artist with an interesting study of structures within the landscape.*

△ **2** *A sketch in pencil, coloured pencil and conté, executed in dreadful weather conditions, provided him with material to work from in the studio.*

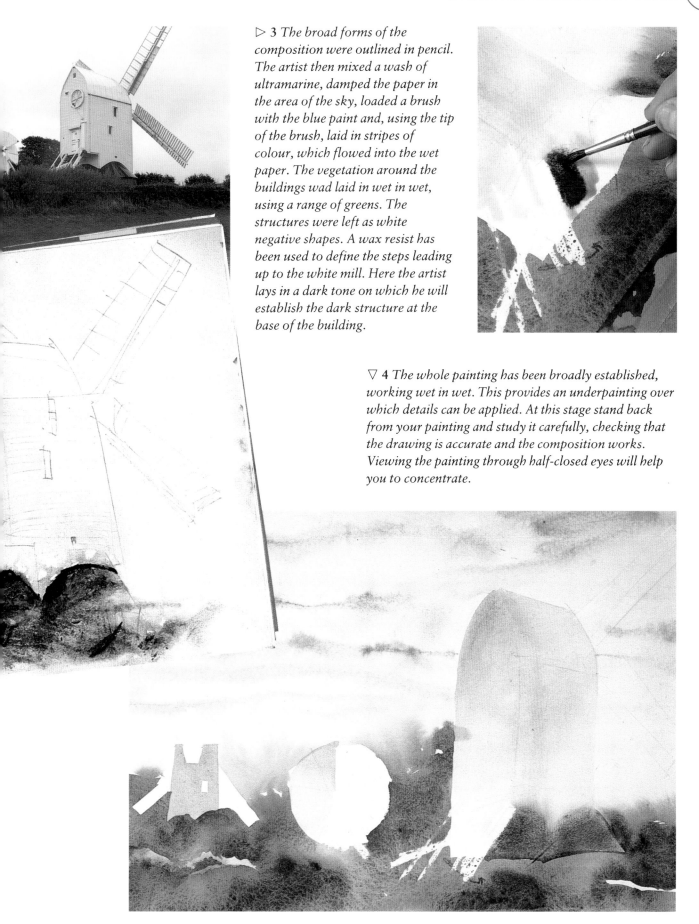

▷ **3** *The broad forms of the composition were outlined in pencil. The artist then mixed a wash of ultramarine, damped the paper in the area of the sky, loaded a brush with the blue paint and, using the tip of the brush, laid in stripes of colour, which flowed into the wet paper. The vegetation around the buildings wad laid in wet in wet, using a range of greens. The structures were left as white negative shapes. A wax resist has been used to define the steps leading up to the white mill. Here the artist lays in a dark tone on which he will establish the dark structure at the base of the building.*

▽ **4** *The whole painting has been broadly established, working wet in wet. This provides an underpainting over which details can be applied. At this stage stand back from your painting and study it carefully, checking that the drawing is accurate and the composition works. Viewing the painting through half-closed eyes will help you to concentrate.*

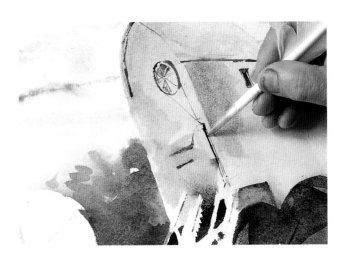

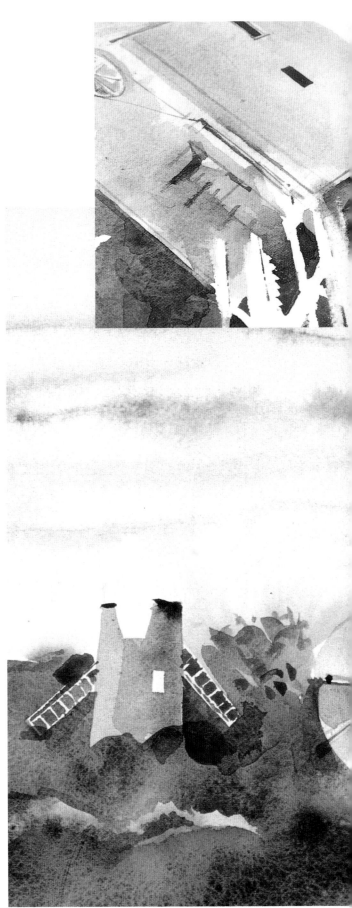

△ 5 *Once the underpainting is established, you can begin to develop the painting, adding colour and texture in the foreground – for example, describing the white windmill with a series of pale washes, and adding fine detail. Don't focus on one part of the painting, but develop the entire surface at the same time, constantly checking one area against another to ensure that they work together. Here the artist adds architectural detail with a quill pen.*

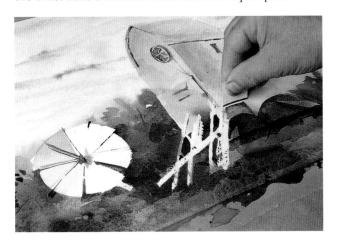

△ 6 *The marks that you make perform two functions. Not only do they describe the subject, but they can also be seen as abstract components of the picture surface. By varying the quality of these marks, you can enhance the decorative quality of the painting. Here a piece of card is used to 'draw' linear detail.*

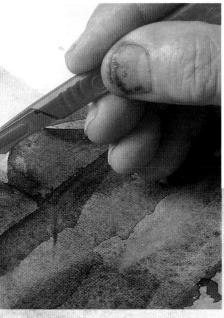

◁ 7 *Here a knife is used to 'draw' detail, scratching the paper surface to create a soft, broken line.*

▽ 8 *Compare this stage with picture 4 on the previous page. You will see that the painting is gradually becoming more detailed and focused. With every painting, you have to decide how far to take the image; knowing where to stop is as difficult as getting started. At this stage the artist decided he wanted to add more detail.*

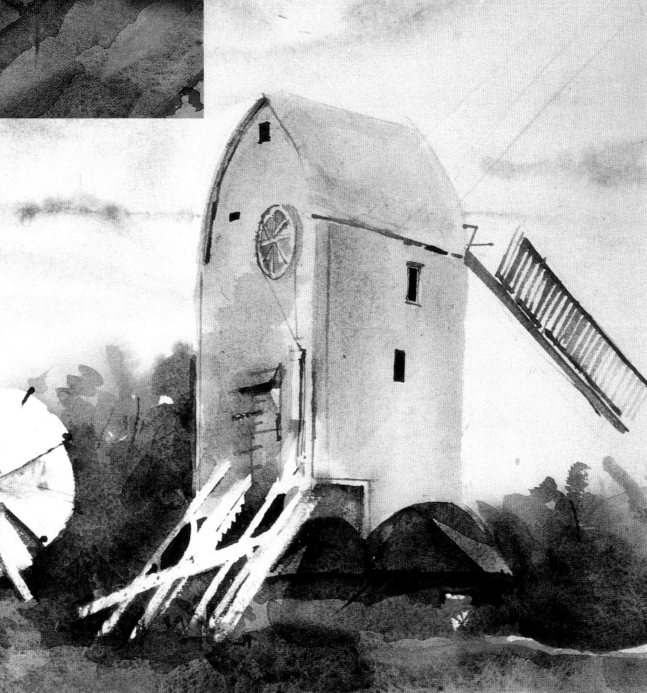

65

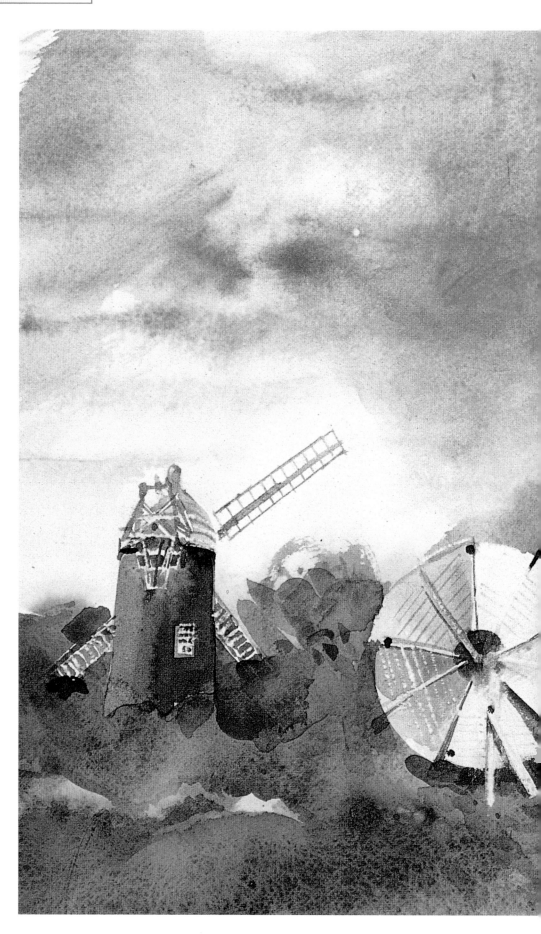

9 *He decided that the painting looked a bit stark. The pattern of whites and blacks against the greens makes a pleasing colour harmony, but the sky doesn't have much presence. He developed the sky with a series of washes to give it more impact. He used a brush-ruled line and sgrafitto (scratching through the top layer of paint) to get the texture on the rear wheel sail.*

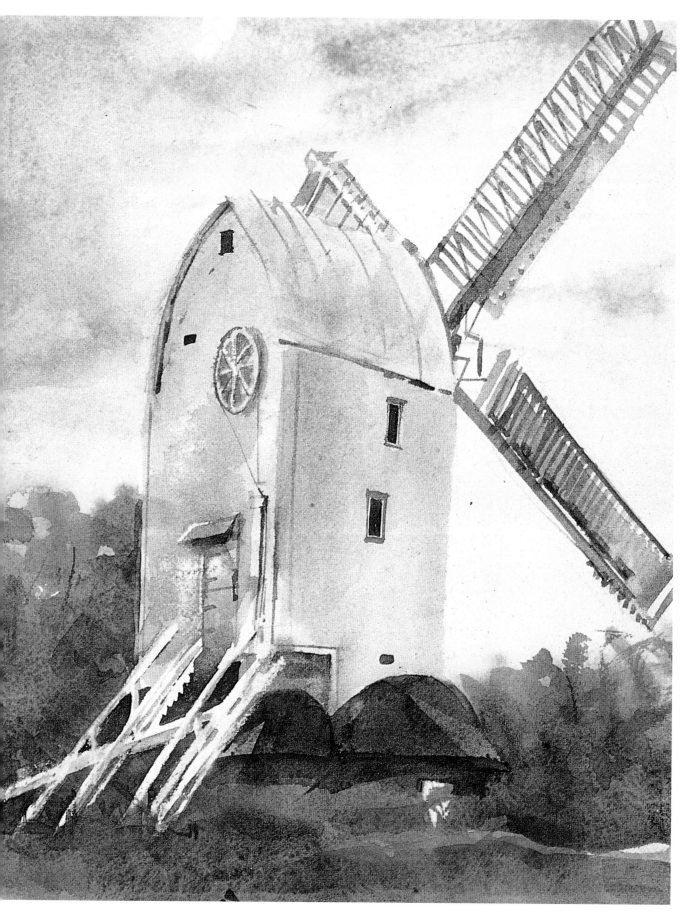

AERIAL PERSPECTIVE

Aerial or atmospheric perspective is a technique which allows the artist to create an illusion of depth in a painting. Whereas linear perspective depends on an understanding of the structure of things and the way our perception of this is affected by distance, aerial perspective relies on contrasts of tone and colour.

As we look towards the horizon, several things happen. First, objects look paler the further away they are. So a tree near to you will look darker than a tree seen in the distance. The contrast of tones also diminishes with distance. Seen from close to, there may be a sharp contrast between the light and dark areas of the tree; the further away it is, the less contrast there will be. If a painting feels flat, you can increase the sense of space by adding crisp details in the foreground and blurring images in the distance. In watercolour this can be achieved simply by working wet in wet in the distance and adding details wet on dry in the foreground.

Colour is also changed by distance. Look at a tree close to you and you will be able to distinguish several distinct shades of green. Now look at a clump of trees in the middle distance. They will be paler and bluer. Hills seen a long way off on the horizon will look distinctly blue.

Warm colours like reds and red-browns are said to advance, while cool colours like blue appear to recede. To increase the sense of atmospheric perspective in your paintings, use blues and blue-greys in the distance and warm colours in the foreground.

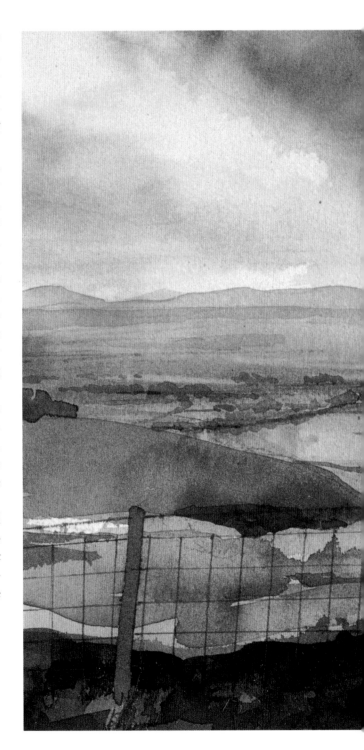

▷ *The foreground is richly coloured and highly textured. This, and the crisply rendered linear detail of the fence posts and the wire, contrast with the landscape beyond, creating a sense of precipitous recession. Warm greens and ochres bring the middle distance forward, while the distant hills are blue.*

◁ *In this photograph you can see the way the trees in the distance appear blue-grey, while the distant hills are distinctly blue.*

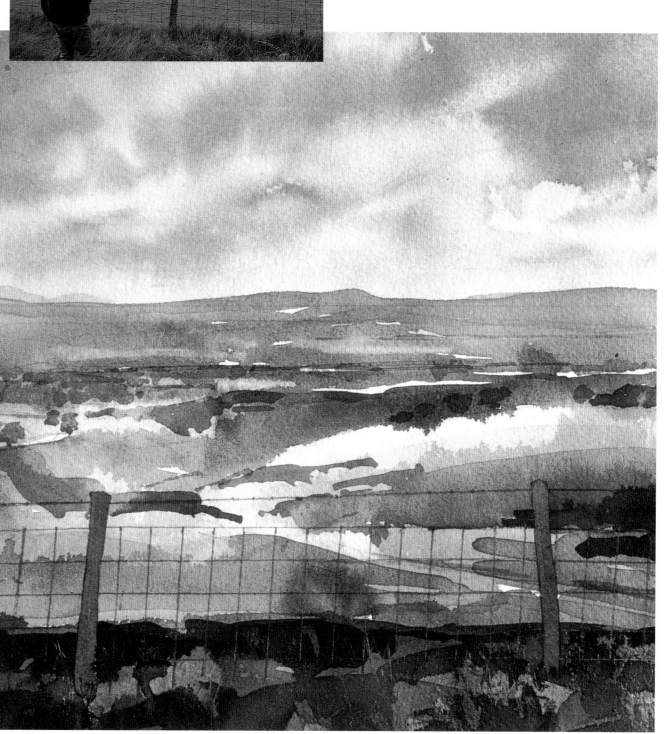

TECHNIQUES

PAINTING TREES

Trees are an important element in most landscapes, so it is important that you should be able to deal with them convincingly. If beginners get into difficulties it is usually because they aren't truly observing. They paint what they 'know' to be there, rather what they can actually see. A tree, like anything else, can be broken down into a pattern of lights and darks and colours. Half-close your eyes and concentrate hard. Put the notion of 'tree' out of your mind and see an abstract pattern.

Here are a few observations which may help you. Different species of trees have characteristic shapes and structure. Take conifers, for example. The Norway spruce, familiar as the Christmas tree, is a tall, slender species, with a tapering crown. The branches are thin and close-set, with slightly upturned tips. The Scots pine has an entirely different shape. It is a tall species, but its branches generally start much higher up than they do on the spruce. The branches are crooked and they grow

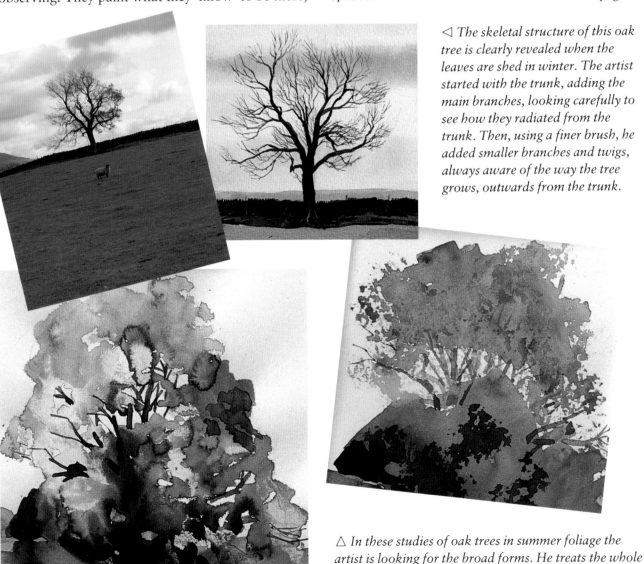

◁ *The skeletal structure of this oak tree is clearly revealed when the leaves are shed in winter. The artist started with the trunk, adding the main branches, looking carefully to see how they radiated from the trunk. Then, using a finer brush, he added smaller branches and twigs, always aware of the way the tree grows, outwards from the trunk.*

△ *In these studies of oak trees in summer foliage the artist is looking for the broad forms. He treats the whole crown as a solid form, constructed of lights and darks. Notice the way that the branches can be seen only in certain places, with the sky behind.*

70

upwards, the dense foliage taking on a distinctively clumped form, with gaps between the clumps.

Think of trees as a human form, with the trunk and branches providing the skeleton which supports the smaller branches and foliage. It is the skeleton which dictates the overall form.

Trees are firmly embedded in the ground by a root system which mirrors the branch system above. They have solidity and volume, and you must convey this, together with a sense of their size, if your paintings are to have conviction. Too often trees are made to look like two-dimensional lollipops, or the flats used in theatrical productions.

Trees have a distinctive growth pattern. There is a main trunk from which the branches grow, and from these the secondary branches and twigs grow. No matter how irregular, trees consist of several dominant branches and their clusters of foliage. Look for the main clumps, the way they hang and the way light catches the top surface, leaving the lower surfaces of the blocks of foliage dark.

Familiarize yourself with the different species of tree. A good reference book will teach you about the way they grow. In some trees, for example, the branches emerge from the trunk in pairs, in others they alternate, and this will obviously affect the overall appearance. There is no substitute for direct observation but, just as a knowledge of anatomy helps the figure artist, so a knowledge of the natural history of trees will help the landscape artist.

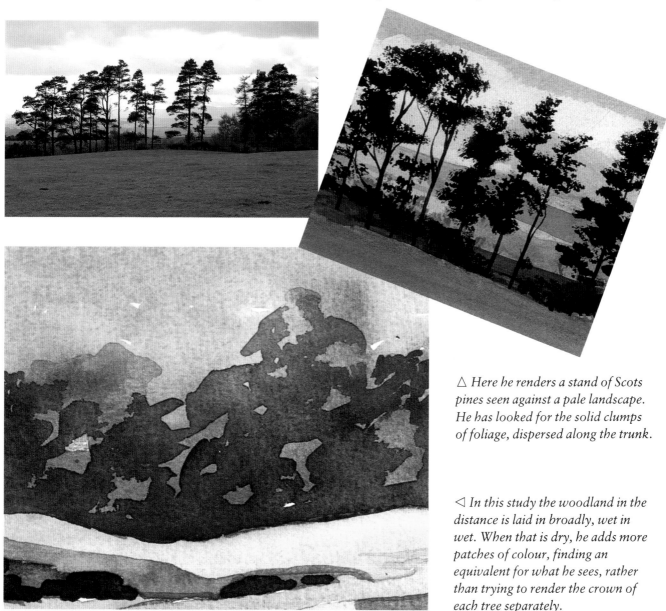

△ Here he renders a stand of Scots pines seen against a pale landscape. He has looked for the solid clumps of foliage, dispersed along the trunk.

◁ In this study the woodland in the distance is laid in broadly, wet in wet. When that is dry, he adds more patches of colour, finding an equivalent for what he sees, rather than trying to render the crown of each tree separately.

PROJECTS

BROAT'S FARM

One of the unkindnesses perpetrated by 'how to' painting books is to imply that professional artists never make mistakes. They show projects progressing in measured stages, always ending up with a pleasing image. But real life isn't like that. Things do go wrong, even for the most experienced artists. But while good artists know when something isn't working, and, more importantly, know what to do about it, inexperienced artists don't always recognize a mistake, and are inclined to struggle on because they can't face wasting all that effort.

This location was glimpsed through a field gate as the artist drove along a country road in Cumbria. He decided to work on a large scale and returned to the location with a 30 × 22 in (76 × 56 cm) sheet of Winsor & Newton paper, rough-stretched on a board. He set up his easel just inside the gateway, which gave him a view across a field to a farmhouse and outbuildings snuggling under the Cumbrian fells. He did a few pencil sketches to sort out the composition, then started by applying a series of broad washes, adding colour wet in wet. He worked fast, trying to capture the essence of the scene.

When he had got as far as he could without overworking the picture, he returned to the studio and continued on it there, using notes, photographs and his recollections of the scene. When it was finished, he studied the painting carefully . . . and decided he didn't like it. The problem was the composition. There were three bands – the sky, the hills and the foreground – and too much horizontal emphasis. The balance just wasn't right. There was too much foreground, for example.

He decided to start again and this time used L-shaped masks to explore compositional possibilities by cropping in to different parts of the picture. The next version – illustrated overleaf – came together easily, and he was much more pleased with it.

The lesson is that you never stop making mistakes, but equally you never stop learning from them. So don't be afraid to take risks.

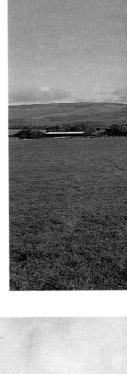

▷ **1** *The artist working at Broat's Farm.*

▽ **2** *Adrian was dissatisfied with his first composition.*

△ **3** *He used masks to explore different 'crops'.*

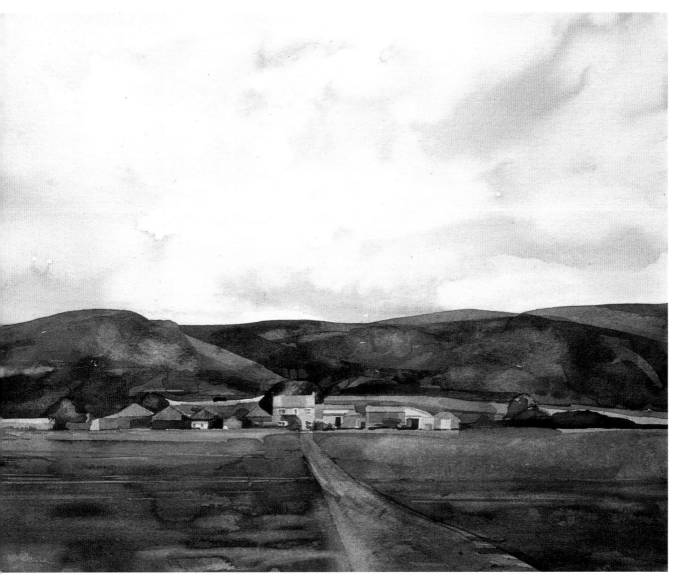

4 *For the final version the artist used a 'not' surface (so-called because it is not hot-pressed and has a smooth surface with a slight texture) and worked on a much smaller scale – the painting is reproduced here at its original size. The artist applied the paint loosely, working wet in wet to start with, leaving the painting to dry before laying on more colour wet on dry. Notice the way patches of colour are allowed to dry with hard edges, which then become an important part of the finished image. The colour in this version is altogether more lively.*

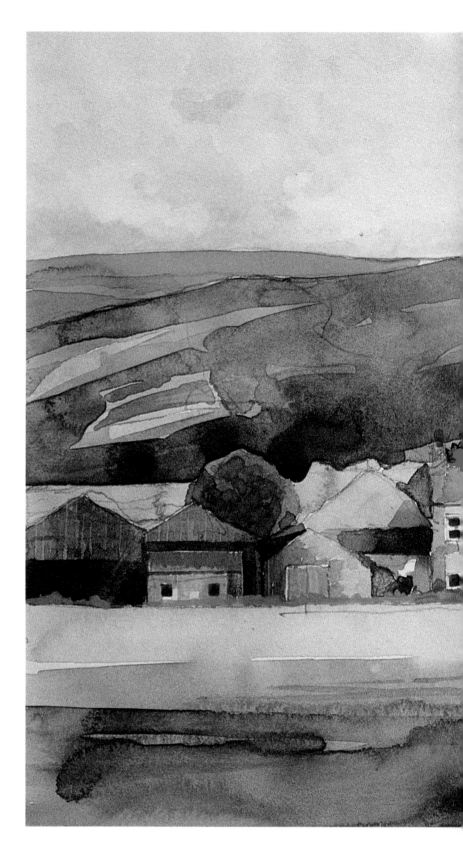

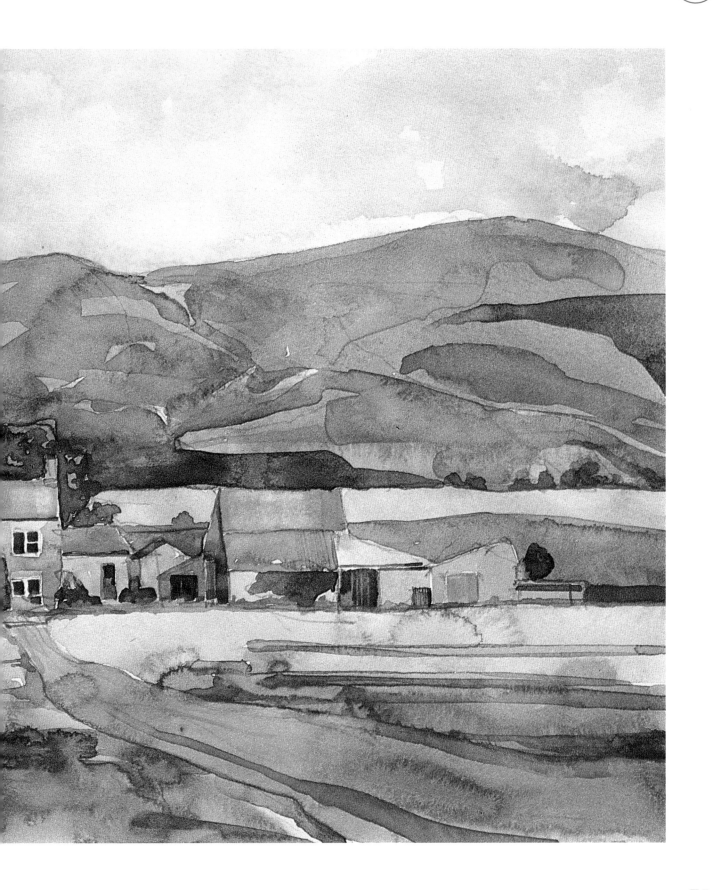

PROJECTS

CUMBRIAN LANDSCAPE

The artist worked fast and furiously to collect materials to work from in the studio. He made several compositional studies in his notebook, a pencil drawing on recycled paper, a very loose watercolour on the same recycled paper and the lively watercolour illustrated on this page.

He was particularly interested in the vivid tones of the autumnal colours. He likes to work wet in wet and then, once the painting gets to a certain stage, leave it to dry. He usually works on more than one watercolour at a time, so that while one is drying he can work on another. A technique Adrian uses to keep the colours fresh is to leave white channels between areas of colour. In this way the wet paint will bleed in a controlled area.

He took this rich harvest of material home and worked on it over a period of time. In the painting on the next page he took the image towards abstraction, breaking the colour into blocky areas, formalizing the areas of tone and colour. By simplifying the forms and colours he brought out the decorative qualities of the subject.

In the final study he moves back towards realism, but the formal qualities of the previous painting nevertheless permeate this work.

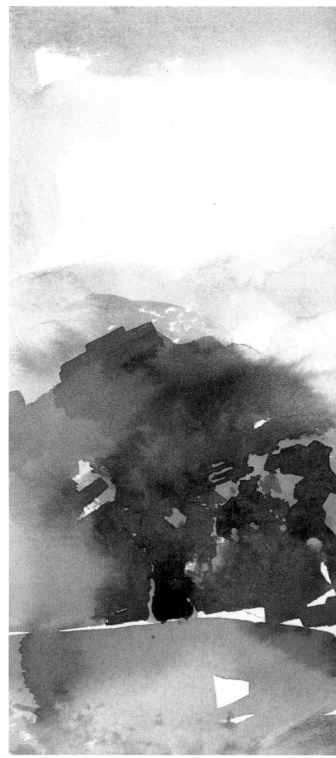

△ **1** *The artist gathering material on location.*

▷ **2** *A pencil sketch made on recycled paper on location.*

▽ **3** *A painting completed on location. The artist worked wet in wet. Notice the white gaps between areas of colour. This allowed him to keep the paint fresh.*

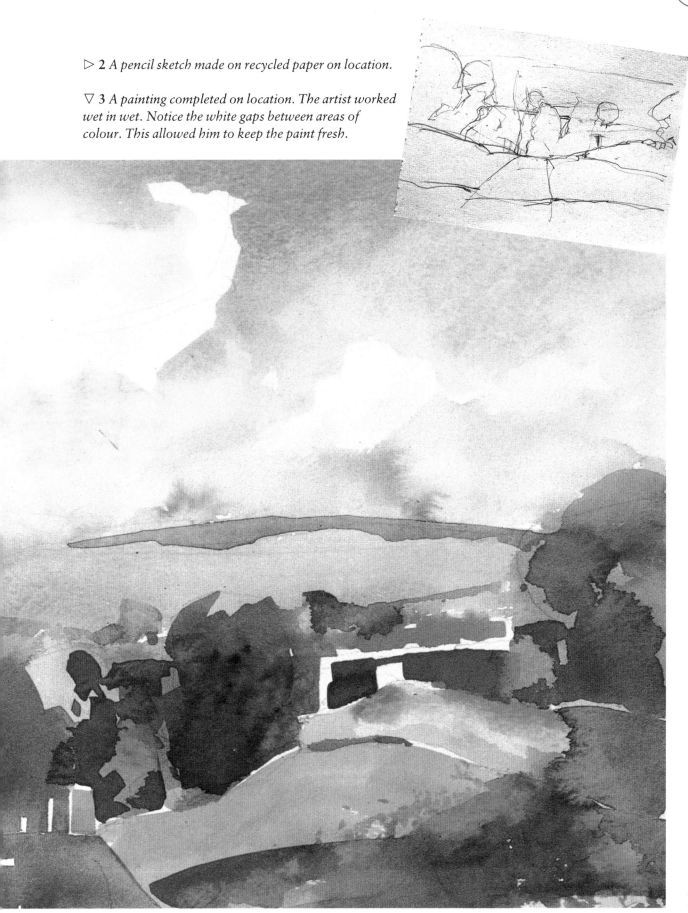

▽ **4** *In the studio, with his reference materials around him, the artist starts a new painting.*

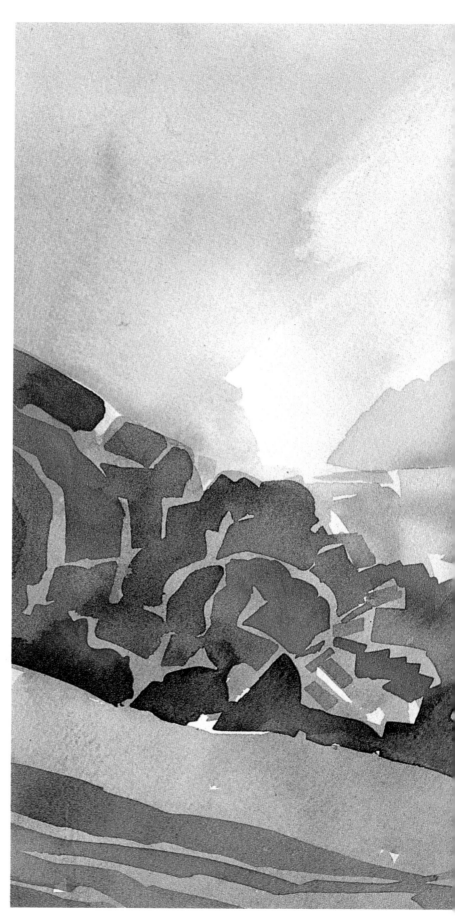

▷ **5** *In this study the artist explores the formal, pattern-making qualities of the subject.*

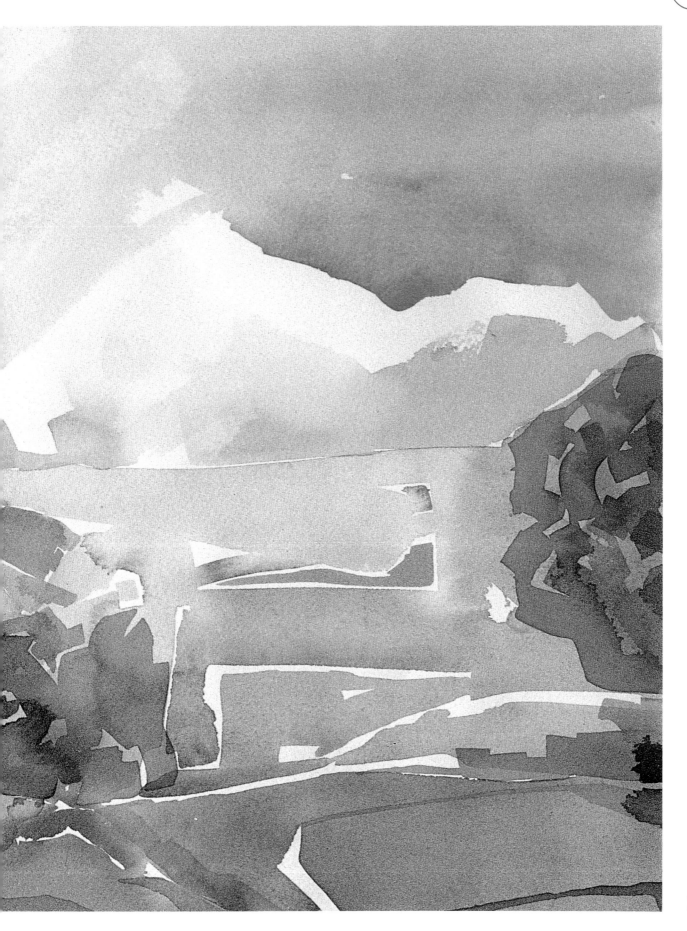

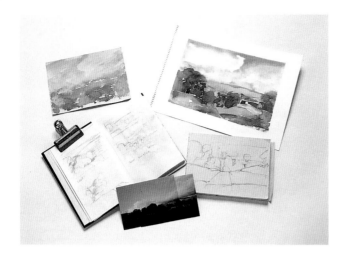

△ **6** *References, including some detailed studies in his sketchbook.*

△ **7** *For the final painting, the sky was laid in with a bold wash applied wet in wet.*

▽ 8 *The finished result combines elements of the other two. Don't be afraid to experiment, and never think you have said all there is to be said about a subject.*

Approaches to landscape

I HOPE I HAVE convinced you that landscape is a fascinating and worthwhile subject, with a great deal to offer the inquiring artist. In this chapter I want to suggest that it is *your* vision of the landscape which is important. You can treat landscape as a jumping-off point for paintings which are as realistic, impressionistic or abstract as you want.

I have talked to three artists who paint landscapes in watercolour. They have different painting styles, but, more importantly, they also have different intentions and concerns. Put all three in front of the same subject and you would get three entirely different paintings – each unique, true to the subject and reflecting the concerns of the individual artist.

Once you have got a few techniques under your belt you can go on to explore and develop your own particular vision. Feel free to make the painting your own. Compose, edit, move, interpret and add as you see fit. Do whatever is necessary to make the picture work for you.

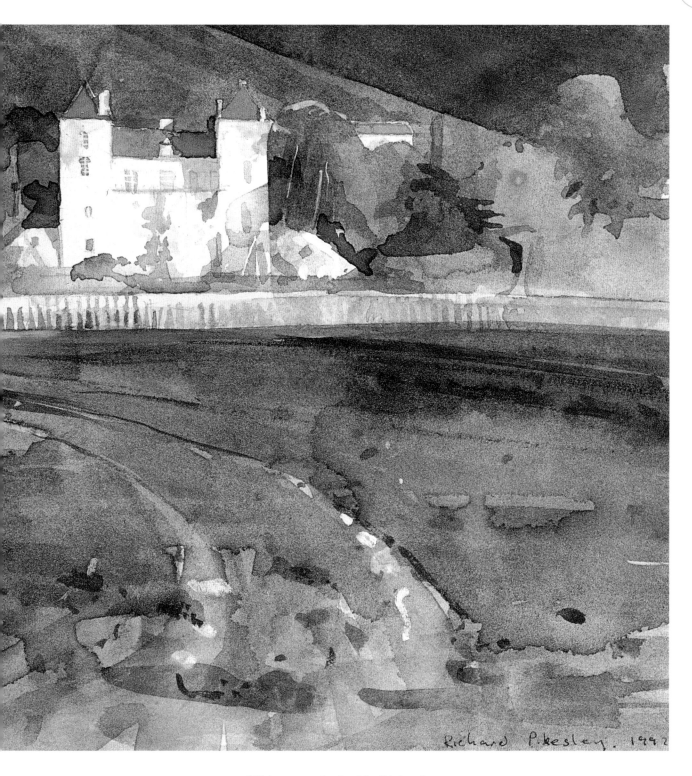

'*Château on the Lot*' by Richard
Pikesley. The artist was captivated
by the contrast between the brilliant
white of the grand building and the
muddy, churned-up texture of the
field of maize stubble. The tracks
made by a tractor lead the eye into
the painting.

83

TONE AND COMPOSITION

Bill Taylor lives in Cumbria, a spectacularly beautiful upland region of northern Britain. He works in watercolour, gouache and acrylic, and concentrates primarily on landscape – local landscapes in particular, often featuring derelict buildings and broken-down walls.

Bill works in the studio from sketches made out of doors. Often these are quite rough. 'I use a sort of visual shorthand,' he says, 'and I depend an awful lot on my memory. It's got to be exceptionally good weather to encourage me to sit there all day and do a drawing.'

He doesn't paint finished watercolours out of doors because the immediacy and directness required when working in those conditions don't allow him time to consider the composition fully. As he says: 'There is generally something which I would have changed quite radically had I had time to sit and think about it a bit more.'

He thinks about the composition as he sketches, frequently moving his vantage point so that he can take in slightly different views, and takes lots of detailed notes. The time between getting the notes down and actually beginning the painting gives him a useful 'cooling-off period' which allows him to think about how he is going to interpret the subject. Before starting on the painting, he does a number of

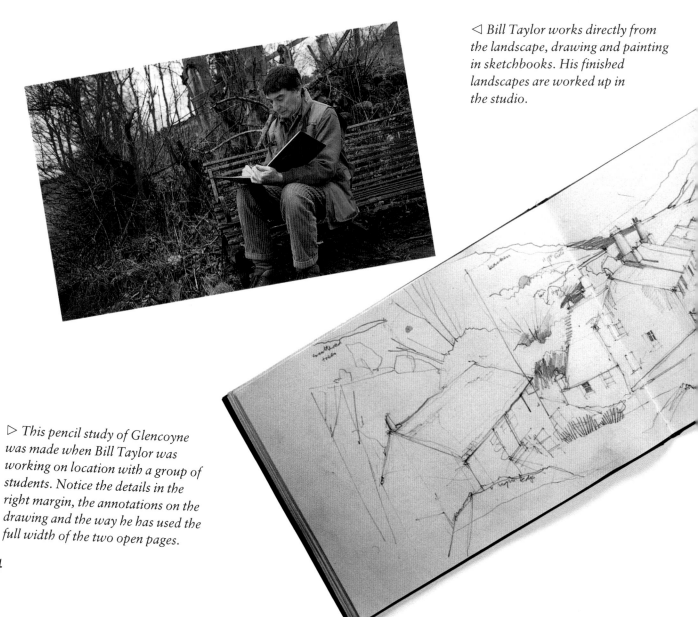

◁ *Bill Taylor works directly from the landscape, drawing and painting in sketchbooks. His finished landscapes are worked up in the studio.*

▷ *This pencil study of Glencoyne was made when Bill Taylor was working on location with a group of students. Notice the details in the right margin, the annotations on the drawing and the way he has used the full width of the two open pages.*

84

thumbnail sketches in which he explores the composition and tonal values, and shuffles things round.

I asked him what was likely to trigger a project. 'It's usually the tonal values that hit me. I can frequently pass a subject several times and not notice it, and then on a particular day, when the light is of a particular quality and from a certain direction, it will give me a shunt. I can pass the same thing time and time again without noticing it.'

He uses pure watercolour, often combining it with pen or coloured pencil. He uses an old-fashioned dip pen, having been given a box of beautiful old nibs by a pupil whose husband was a retired bank manager. He likes to think of pens intended for work on ledgers finding such a creative use. He uses pen with paint rather than with ink,

loading it up with watercolour from the brush. He can make better lines with a pen than he can with the brush.

He also uses a reed pen, having collected some excellent reeds from a lake in southern France and sharpened them with a razor blade.

Bill uses a very limited palette of colours: quinacridone rose, cadmium red, cadmium yellow, cadmium lemon, ultramarine and cerulean blue. He encourages his students to stick to those six, but, as he says, 'I allow myself the luxury of Prussian blue, because it is so radically different to the ultramarine and the cerulean. I also use raw sienna, although I could mix it from one of the reds and one of the yellows, but I use a lot so I can justify buying it.'

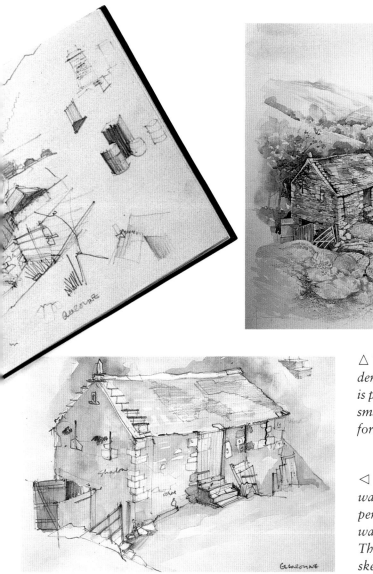

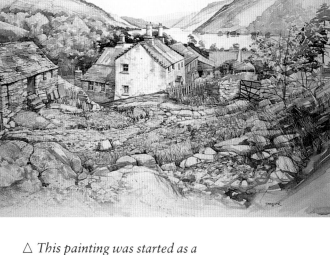

△ *This painting was started as a demonstration and finished later. It is primarily watercolour with a small quantity of gouache in the foreground.*

◁ *This detail of the farm building was also made on site. He worked in pencil and then dropped some watercolour washes on to the paper. This was one of a series of four sketches made on location.*

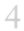
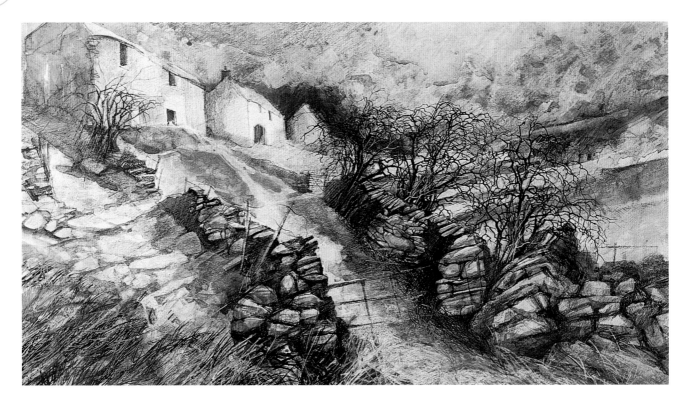

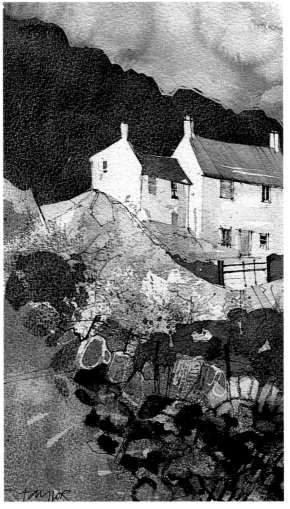

◁ Tyne Head, in the Pennines, is the subject of this wintry study. Bill used watercolour, and gouache mixed with acrylic medium as a glaze in the foreground. He has managed to capture the crispness of the frosted grass in the foreground. The picture is about 20 × 35 inches (50 × 87.5 cm) and is on illustration board.

◁ ▽ This small study, 10 × 4 inches (25 × 10 cm), of Boardale in the Lake District, was made on Bockingford paper. Bill masked out the white of the buildings so that they showed against the dark hill in the background. He also masked some of the line work in the foreground, adding some ink in this area.

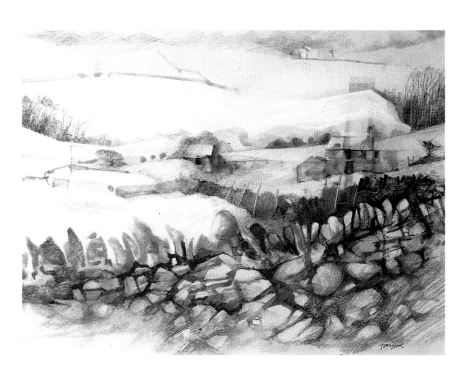

△ For this painting of Alston Moor under snow the artist used illustration board. He laid in the broad forms of the painting in sepia, using brush and pen, and then worked into that with a water-soluble pencil. In the foreground he scratched the surface, using a coarse sandpaper to create textural interest.

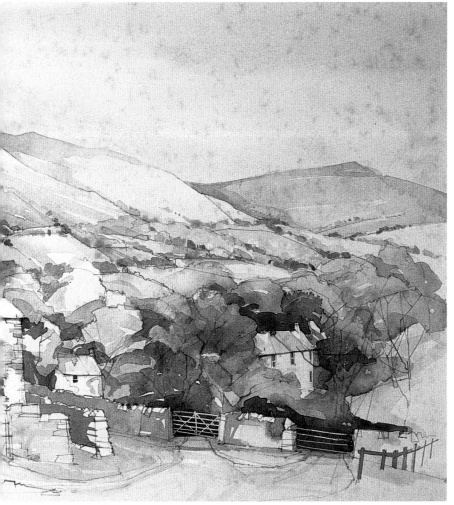

◁ Sandwick is a tiny hamlet in the Lake District. The artist painted this in autumn, again while working with one of his student groups. He used delicate washes of watercolour to create a light, airy, autumnal feel with very little tonal contrast. Compare this with the Tyne Head study, which is much bolder and more contrasty. Here he used Fabriano hot-pressed paper, which allows him to achieve delicate blends of washes.

87

STRUCTURE, COMPOSITION AND DESIGN

Ian Sidaway works in watercolour and oil. In his large oils he generally deals with figurative and still-life subjects. In his watercolours he covers a wide range of subjects, but landscapes form a considerable part of his work.

He enjoys watercolour for its subtlety, for the range of effects it allows him to achieve and for the speed it gives him. As he says, 'You can get a picture finished in a day.' His favourite additive is gum arabic, which intensifies the colours and enables him to lift off the colour by rewetting the paint and blotting it off. 'It's terrific for highlights and texture and fine lines.'

His watercolours are created as an end in themselves, often as a record of places he has visited, but they may also be used as a preparation for large oils. He thinks of them as 'moments caught in time, snapshots, glimpses of an event or a scene'.

'All my preparatory work for paintings is done in watercolour. It's good for working up variations of things, for working out colour and how things are going to look before I get down to painting a large canvas. I can do two or three alternatives.'

He works from photographs taken with a view to building them up in watercolour later. If he finds a subject that interests him, he takes several photographs, framing them in different ways. 'Sometimes I go through the photographs and see absolutely nothing that hits me. Then I go back to them, and go through them again, and find that there are things shouting out to be painted,' he says. He may create an image from an amalgam of several pictures.

Ian is interested in series paintings – images created over a period of time. 'You keep seeing different things.'

He uses a limited range of colours: Payne's grey, cobalt, cerulean blue, ivory black, cadmium yellow and yellow ochre, brown madder alizarin ('which I

▷ In this lovely formal painting of an olive grove Ian Sidaway has created an image which captures the contrast between the cool under the trees and the heat of the sun above. His crisp paintwork emphasizes the decorative quality of the repeated forms of the foliage, but he has found a way of rendering the foliage without drawing it leaf by leaf.

◁ Here bold, dark trunks of the trees in the foreground and the foliage cut the edge of the painting at the top. Athough this is a landscape composition, it has an architectural feel, and the artist has emphasized the strong verticals and horizontals.

△ In this study the gable end of a building is seen flat on, so that there is no linear perspective. The way that the apex of the roof is clipped by the edge of the picture area divides the sky into two geometric blue shapes. The lettering of the advertisement on the end of the building is an important component of the painting.

use for red'), cadmium red, chrome orange and sepia. He also uses sap green and viridian. 'I'm not averse to using anything – if I want a purple I'll use it. I'm not strict about sticking to this palette.'

He is interested in design and composition, and all his images are very solidly and often surprisingly constructed. He has an absolutely instinctive feeling for design. In some of his paintings he makes brilliant use of space, treating it as an integral part of the image rather than just 'emptiness'. He is also interested in the graphic qualities of architectural drawings and prints, and this shows through in his own work. When he does undertake an architectural subject, he often chooses an end-on view which has no perspective, and crops in to it so that it fills the picture area, emphasizing the abstract, pattern-making qualities of the subject.

Another recurrent theme in his painting is the quality of strong light and the way it emphasizes, exaggerates and sometimes dissolves forms.

◁ This painting illustrates the artist's love of architecture, formal composition and the qualities of light. Here the brilliant light provides wonderful, harsh contrasts, and the shadows of the pot plants become strong, dark shapes, as important as the pots themselves.

▷ The artist studies the play of light across a stone and broken plaster facade. The building and the car are seen straight on, minimizing the spatial elements in the picture and emphasizing the abstract geometry. The painting is primarily neutral so that the flowers in the window-boxes look brilliant by contrast.

91

TOWARDS ABSTRACTION

Adrian Smith came to landscape via a circuitous route. He trained as a theatre designer and now works freelance in the film industry. He realized that he needed to get ideas down on paper very quickly, and to represent what he was constructing accurately so that he could communicate his ideas, and found that watercolour was ideal for this. Portable, quick and very expressive, it is also a marvellous medium for capturing light and shade – a major component of the design of any film.

From this very practical application, he became interested in the possibilities of the medium. He went right back to basics, teaching himself all the different watercolour techniques, and now he is so comfortable with the medium that he can concentrate on the process of picture-making.

He became increasingly interested in landscape and seascape. Most of his early work was fairly literal, but, over the last seven or eight years, he has become more concerned with exploring the landscape rather than merely describing it. 'I have been really pushing the landscape, exploring aspects of it, looking at things like colour, form and tone.'

This interest culminated with Adrian's move out of town and into the countryside. 'Now it is a question of looking out of the window and there it is. I am beginning to see the landscape in a very different way now, exploring the hidden elements and the geometry.' He likes this complex, layered approach, which brings in elements of art history, sacred geometry, the concept of wilderness and man's influence upon the landscape.

His concerns are constantly changing, as he

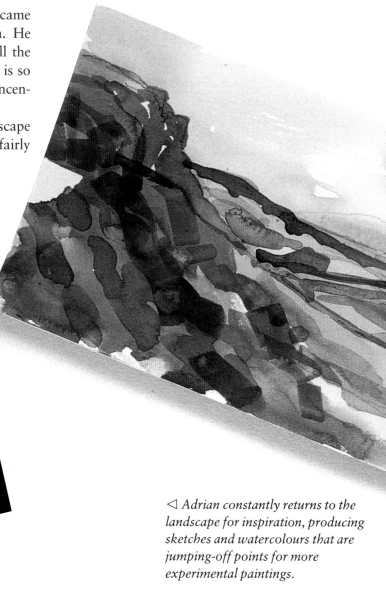

◁ *Adrian constantly returns to the landscape for inspiration, producing sketches and watercolours that are jumping-off points for more experimental paintings.*

explores first one theme and then another, taking an idea as far as he can push it. Though his paintings are always rooted in the landscape, they often develop into abstract and semi-abstract interpretations, expressed as pure colour and form. But this is a cyclical activity, for he always returns to the landscape, working directly from it in a conventional, representational way. His heroes are artists like Samuel Palmer (1805–81), who imbued the landscape with his own mystic vision, and Turner (1775–1851), who also distilled his own unique and magical vision of the landscape.

Adrian's basic palette includes cobalt and cerulean blue, indigo, Payne's grey, aureolin (a light yellow), which he uses to warm skies and create clean greens, cadmium yellow, lemon yellow, yellow ochre, raw umber, burnt sienna or Indian red, burnt umber, olive green or sap, alizarin crimson, vermilion and cadmium red. He also uses viridian which can't be mixed from any other colours on your palette but is useful mixed with other colours. 'You have to watch it, though. It creeps and tends to alter the whole balance of the thing.'

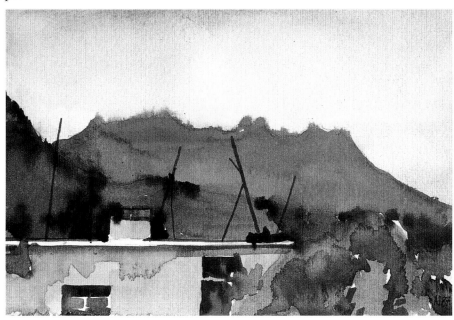

▷ *This view of Mount Hilarion in Cyprus is one of a series made on holiday. The artist had to work quickly to capture the fleeting light effects as the sun went down. He made several paintings at once, so that he could work on one as the other was drying.*

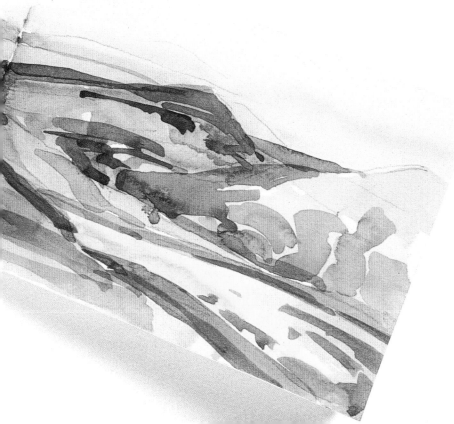

◁ *This colour sketch of the Derbyshire countryside near the artist's home was made directly from nature on a hot, sunny afternoon. He used a wet-in-wet technique, but the hot sun dried the wet washes, allowing him to work quickly.*

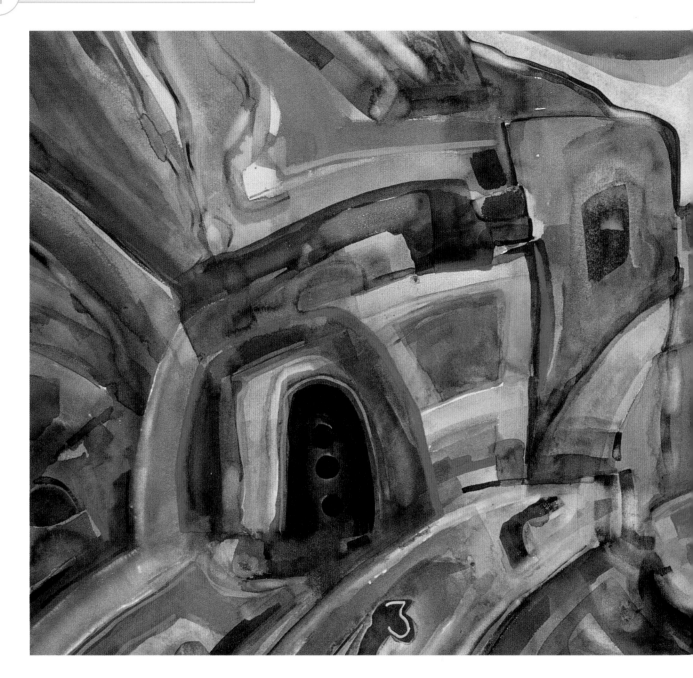

◁ This image is based on a view of the garden at the artist's home. The initial drawing was done with printer's ink and oil paint on a rough wooden block; he made a monoprint, the rough wood giving the image a textured quality. Thin washes of watercolour were then applied over the oil and ink, which formed a resist.

△ This is a working sketch for a larger watercolour painting. The artist used it to work out the composition and colour.

▽ In 'Nocturnal Landscape', a working sketch for a larger painting, the artist investigated the contrast between natural and man-made forms.

◁ This painting, 'Odin Mine 3', is the third in a series of studies based on ancient Roman lead mines which were worked by slave labour. Adrian was interested in both the physical landscape and the historical background. The colours and compositions were designed to reflect the oppressive atmosphere of the subject. This painting is moving towards abstraction – later paintings in the series become totally abstract.

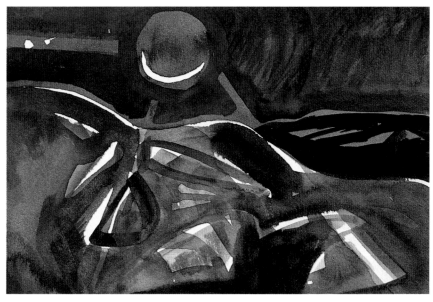

95

INDEX